DEVELOPING STYLE IN

Watercolour

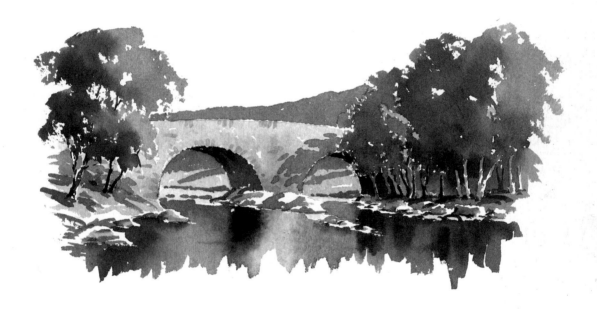

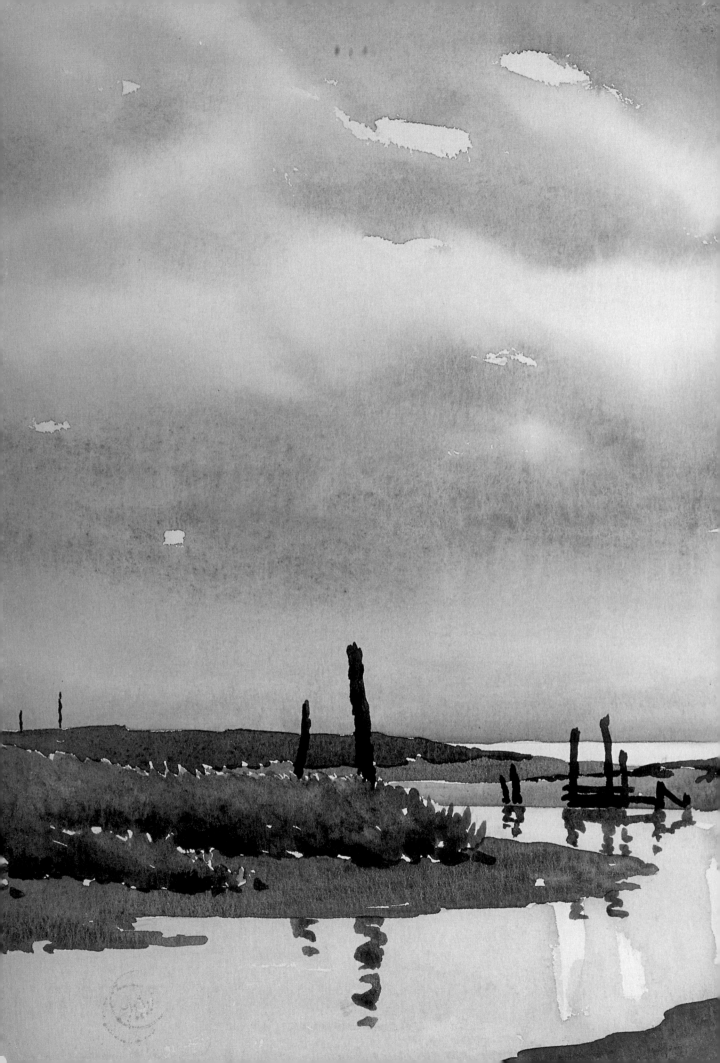

Developing Style In

Watercolour

Ray Campbell Smith

David & Charles

DEDICATION

To my family, my friends and fellow painters and to all those
who share my love of pure watercolour.

Illustration previous page: *Norfolk Creek*

ACKNOWLEDGEMENTS

I would like to thank my editor, Alison Elks, for her valuable help
and advice; my son Paul, MA (RCA), BSc.(London), for his
excellent colour photography; Maureen Gray for deciphering
my longhand and converting it into orderly typescript;
Lord and Lady Sackville for kindly allowing me to use paintings
of Knole House in their collection; and my wife, Eileen, for
her constant help, encouragement and support.

A DAVID & CHARLES BOOK

First published in the UK in 1992
First paperback edition published 2001

Copyright © Ray Campbell Smith 1992, 2001

Ray Campbell Smith has asserted his right to be identified as author of this work in
accordance with the Copyright, Designs and Patents Act, 1988.

A catalogue record for this book is available from the British Library.

ISBN 0 7153 1167 0

Printed in Singapore by CS Graphics Pte Ltd
for David & Charles
Brunel House Newton Abbot Devon

CONTENTS

INTRODUCTION

Style in painting is a many-sided and elusive thing and since an author's opinion and perhaps prejudices are bound to come through in his writing, there is a danger that the expression of his personal views may give a lopsided impression. By inviting other painters, all with well developed and individual styles, to contribute work and opinions, I believe we have together achieved a more balanced and objective picture. This book, by presenting and analysing a number of different approaches, will help you to develop your own personal style.

The work of accomplished and established painters is instantly recognisable and bears their own unmistakable stamp. Just as the longhand writer naturally develops his own particular pattern of writing, so the artist acquires, over a period of time, his own individual style of painting. It is this style which distinguishes one painter from another and tells us something of the way in which they see the world about them. The aspiring amateur painter is often painfully aware that his work is deficient in that desirable quality and sets out purposefully to

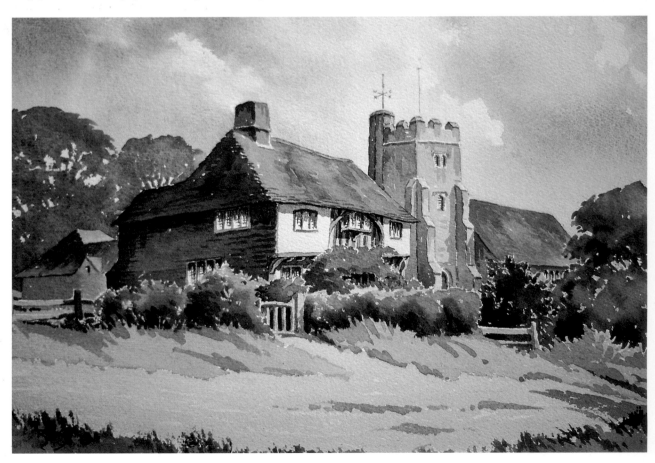

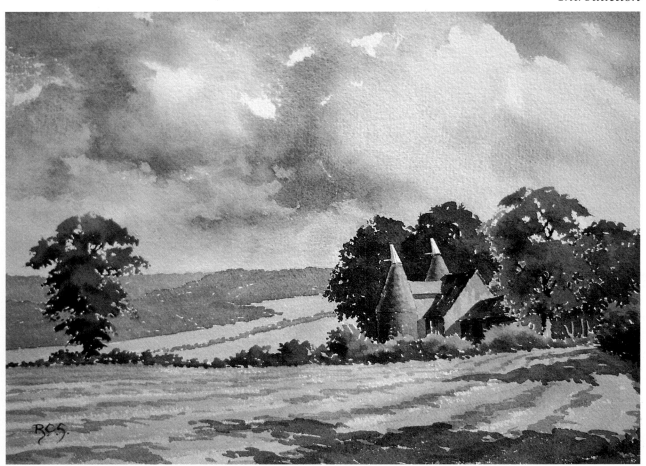

GOUDHURST FARM

In this painting the group of Kentish farm buildings nestling in a sheltering stand of trees, is balanced by the heavier clouds, the blue-grey distance and the single oak tree on the left. The lines of mown hay in the foreground field have been indicated by loose brush-strokes and lead the eye into the centre of interest, the group of buildings. Trees not included in the painting cast their shadows across the foreground, to lend a little variety to an otherwise rather empty area. The progressive greying of the distance creates a feeling of recession and contrasts with the warmer colours of the foreground.

◁ STONE-IN-OXNEY

In this painting most of the interest is in the mediaeval farmhouse and church, so the sky was indicated very simply. The distant trees were painted with the side of the brush and the roughness of the paper helped to produce their broken outline. While the greenish wash was still wet, a mixture of ultramarine and light red was dropped into the shadowed areas of the foliage.

I made no attempt to straighten the rather wayward lines of the old oak-framed farmhouse for they help to convey something of its character. The old tiles were mainly burnt sienna, with a little green added to the lower courses to denote moss and algae. When this wash was dry a little texturing and weather-staining was added, with the brush-strokes roughly following the slope of the roofs.

acquire a style of his own. This he sometimes does by consciously assuming the mannerisms of painters he admires, only to find that this road leads nowhere and that his work merely becomes a pale and ineffective imitation of the real thing. It has been said that a painter's style is the outward expression of his own personality and is his handwriting in paint. This I believe to be true and it explains why the attempt to adopt another painter's style is doomed to failure. What, then, should he do?

The old masters never considered style to be an end in itself and were not concerned with it in any active sense. Their search was for excellence, and by following their own paths to that end, individual styles developed along the way. The fact that true style evolves gradually over a long period of time is shown by the manner in which the master painters developed during their lifetimes. That great modern stylist, Rowland Hilder, once wrote 'It is the business of the student to find and develop a method best suited to his own temperament' and in another essay 'I don't want to pick up modern tricks of style. I have just got to develop my own way'. Words of wisdom indeed.

Art teachers are sometimes accused of being rather negative in their approach, of simply telling

7

their students what to avoid rather than what to aim for. There is a certain amount of truth in this charge, but it must be remembered that motivation must spring from the painter himself, and the way he directs and develops his inspiration must come from him. The teacher can best help by guiding him round the more dangerous pitfalls. In the matter of style, it is possible to be more positive than this and do more than merely list the factors that inhibit its development.

What is it that prevents many painters from producing work of strength and character? Why is it that their best efforts are often flat, uninspired and devoid of style? There are a number of answers to such questions and these we shall examine in the following chapters. We shall also suggest ways in which painters may develop their own style by improving and refining their technique. The style which develops will then be a genuine one which will complement and enrich their work and reveal something of their own vision and personality.

Timidity and lack of confidence are perhaps the main inhibiting factors, for no one can paint with style and panache if his main preoccupation is the careful avoidance of technical faults. It is entirely understandable that the inexperienced artist is anxious not to ruin his expensive watercolour paper and takes obsessive care to avoid doing so. Sadly, this concern with safety has a deadening effect upon his work; tightness creeps in and effectively prevents the growth of a free, fluid and personal method of applying paint. This frequently happens when over-detailed and too complete drawings are made of the subject, for then the painting simply becomes a matter of colouring a series of carefully drawn shapes, rather in the manner of a child's colouring book, and this is death to the development of lively and spontaneous brushwork.

FOUR WENTS FARM

A day of sunshine and showers in the Weald of Kent suggested a lively sky with billowing cumulus clouds – and quick execution before the next downpour interrupted proceedings. I used masking fluid to preserve the white of the oasthouse cowls and so avoid the difficult task of trying to paint round them with a large brush and a full wash. Bold brushwork, using the side of the brush on the rough paper, produced the broken outline of the trees. Quick, horizontal strokes of a large brush suggested the texture of the foreground grass.

Notice how the curve of the farm lane leads the eye into the centre of the painting and how the lateral shadows on the right break up its rather too definite line.

The way we handle a pen influences our handwriting and in similar fashion the way we wield a brush affects the character of our painting. It

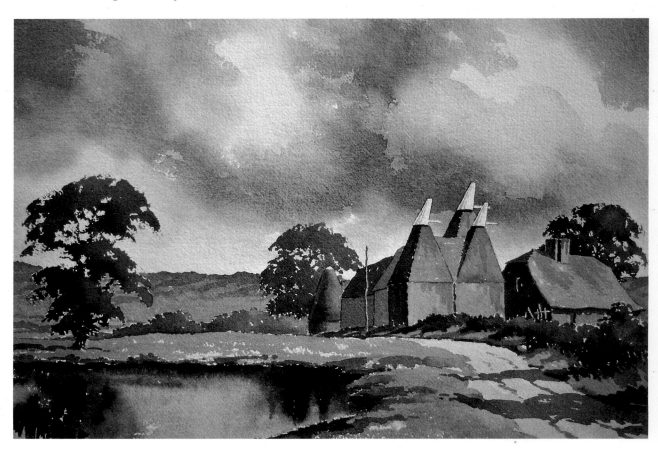

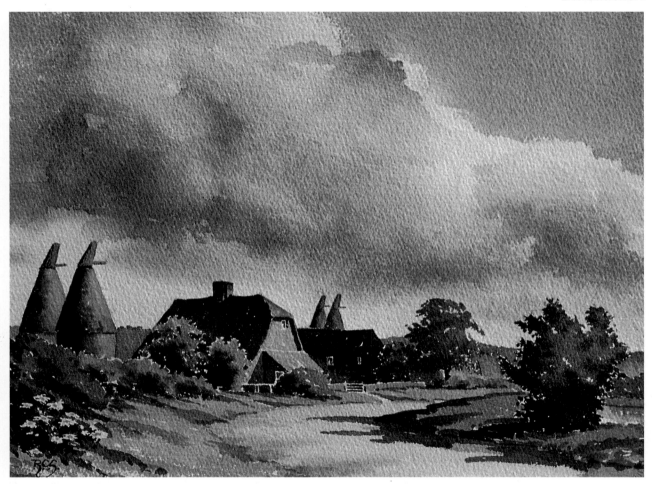

behoves us, therefore, if we wish to develop our natural style, to give our brushwork free rein. What this means in practice is to avoid cramping freedom of expression through indulging in an excessive amount of over-meticulous drawing. Far better to rely upon a minimum of guidelines and then let lively brushwork achieve our effects. This important topic is dealt with in more detail in Chapter 4.

Composition, which is simply the way in which artists arrange their subject matter on their paper, is another important ingredient of style. Few artists paint literal or photographic representations of the landscape in front of them. They alter the arrangement of its features to improve balance and they omit details which contribute nothing of value to the painting. The manner in which these changes are made varies from artist to artist and so influences the development of their individual styles. Lively and original composition may strongly complement bold and effective brushwork to produce paintings of strength and style. The beginner is frequently so obsessed with striving to improve his painting technique that he fails to give sufficient thought and attention to working out his composition and falls back on safe and often dull arrangements of his sub-

LADDINGFORD

This Wealden village was painted on a blustery day with alternating sunshine and cloud shadow and the low horizon gives due prominence to the lively sky. These conical oasthouses are a feature of the Kentish rural scene. A few are still used for drying hops but the majority are being converted to other uses and the rich aroma of drying hops that pervaded the Weald in autumn is, sadly, a thing of the past. Here their vertical forms stand out boldly against an area of pale sky just above the horizon and even the white cowls appeared quite dark. Masking fluid was used to preserve the shapes of the dog daisies in the left foreground.

THE RIVER AT EYNSFORD

This is a painting I did as a demonstration to an art group – not the best way of producing a masterpiece as one's concentration on the business of applying paint is constantly distracted by the need to keep up a running commentary on what one is doing, answering questions and so on. My object was threefold: first to demonstrate the way to indicate light on a fairly complex subject by careful attention to tone differentials, second to indicate a method of tackling trees without resorting to fiddling detail and, third, to show how to suggest smooth water without recourse to the mirror image. I kept the warm evening sky very simple to avoid any suggestion of competition with the busy scene below.

ject matter. It always pays to look beyond the obvious and conventional viewpoint and seek a more original angle which may help to bring out and accentuate the character of the subject. A number of quick sketches from various positions may well result in the discovery of something both telling and original, and we shall explore this particular avenue in Chapter 3.

All experienced painters have their own favourite range of colours, in other words their own personal palette. True, these often change and evolve over time and may well also vary in the short term accord-

ing to the subject matter in hand. But we still recognise the work of individual painters not least by their typical use of colour and so that, too, becomes an ingredient in the complex matter of style. Painters vary greatly in the importance they attach to colour. With some, colour is everything and form and composition take a back seat. With others, draughtsmanship is more important, and with them colour is a secondary consideration. Between these two extremes are an infinite number of variations.

As we noted earlier, an artist's style develops over his working life. He may not be aware of this development but it is none the less true that experience teaches him how to obtain more spontaneous effects, and this applies with particular force to the watercolourist. Sometimes these discoveries are accidental – the happy accidents of art folklore – but they then become part of the technique and hence of the style of the painter concerned. This is as it should be – style should be flexible and capable of adaptation and growth, for progress ceases when it becomes static and ossified.

Occasionally a broad intellectual movement may influence profoundly the styles of many contemporary artists as, for instance, when there is a wide-

CANALSIDE SCENE

Venice and its surroundings provide irresistible subject matter for artists and there seems to me to be an appealing composition at almost every turn. In this typical glimpse I was attracted by the jumbled shapes of the canalside buildings and by their rich, warm colours. The lateral light cast bold shadows which helped to give the houses a three-dimensional appearance. The church tower, placed a little off centre to the right, makes a useful vertical to balance the strong horizontal lines of the road and the canal. The soft reflections complement but do not compete with the busy scene above.

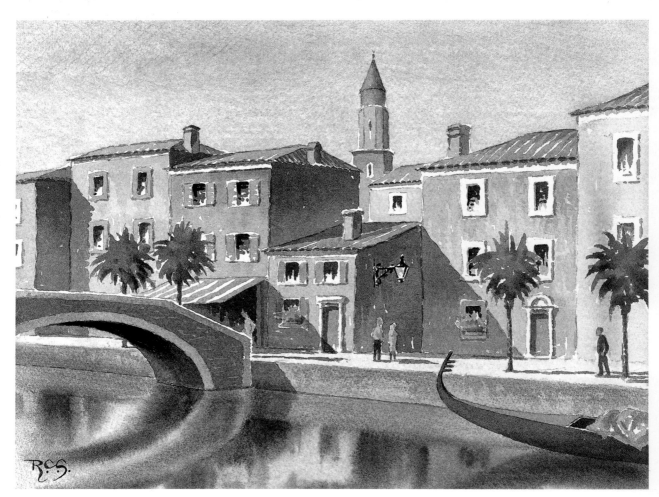

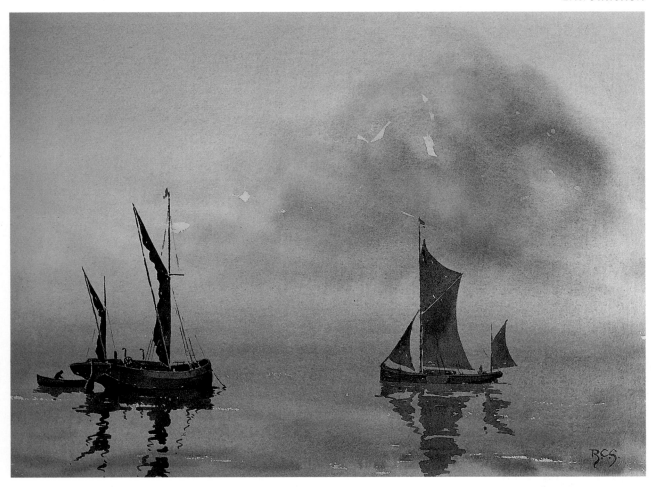

spread revolt against the tastes and techniques of the existing artistic establishment. When the Impressionists rebelled against the smooth and exact classical tradition and set out to capture light, atmosphere and feeling, detail was sacrificed, livelier palettes were used and far bolder brushwork employed. The styles of all those caught up in the movement changed dramatically, but this was not a conscious change in technique for its own sake but rather a natural response to the way in which painters began to view the world about them. This may be regarded as a genuine development of style to a particular end, far removed from the conscious exaggerations of some more recent painters.

Sailing Barges

A warm summer's evening with a low sea mist obscuring the horizon and the surface of the water calm enough for fairly definite reflections. The sky and sea began as a variegated wash of pale ultramarine at the top merging into raw sienna at the horizon, with more ultramarine at the bottom, to produce a pale green for the sea. While this wash was still wet I removed some of the blue in the sky and dropped in some pale raw sienna for the cloud, adding warm grey cloud shadow with a mixture of ultramarine and light red. With the same grey, plus a little more light red, I painted the area of sea mist at the horizon. Only when the paper was completely dry did I add the sailing barges and their reflections, using fairly rich colour to make them register strongly against the pale background.

MATERIALS AND STYLE

The starting point for any discussion of style must be the consideration and assessment of materials, for these play a vital part in the quest. The inexperienced often fail to realise this and make do with unsuitable paints, papers and brushes, mainly because they do not know what is on offer and do not understand how the proper choice of materials will help their work – and, indeed, flatter it. I have found this to be particularly true where watercolour paper is concerned and some students go on using the sort of paper provided, for reasons of economy, by most schools. Cheap papers fail the test of suitability in a number of ways but two deficiencies are particularly serious and make first-class work a virtual impossibility. The first is weight, for here any attempt to apply good, full washes will result in gross cockling and surface distortion whereby the liquid paint settles in pools in the depressions, and

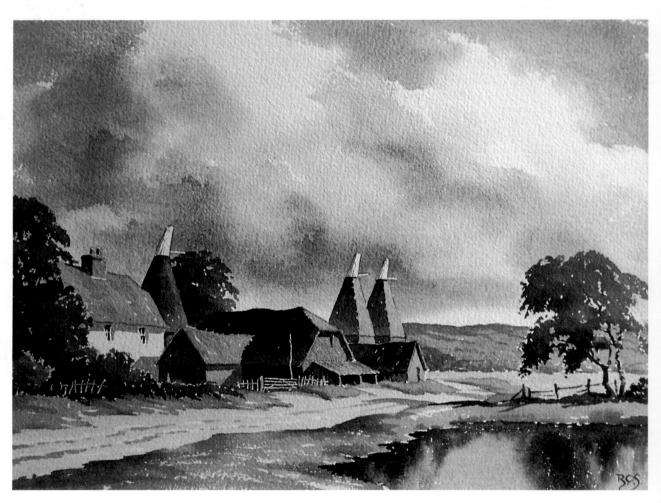

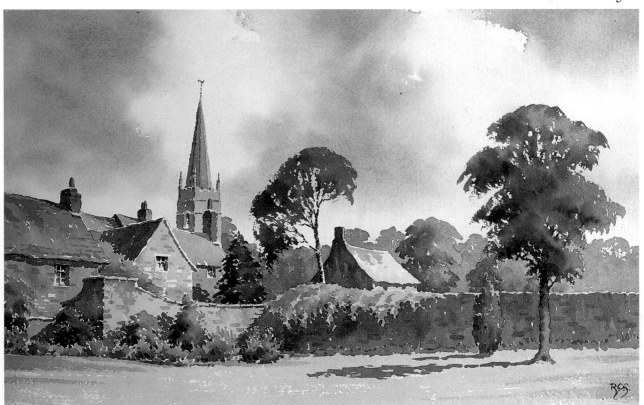

WENDY'S GARDEN

The sunlight is an important factor in this Cotswold village scene and the strong contrast between the sunlit and shadowed elevations of the honey-coloured stone buildings contributes to their three dimensional appearance. The light just catching the top of the length of shadowed garden wall, the gradations of tone in the octagonal church spire and the foreshortened tree shadow falling across the lawn all play their part in creating the illusion of pale autumn sunshine.

The church spire makes a strong statement against its patch of pale sky and, together with the group of cottages, is balanced by the strongly painted foreground tree on the right. The distant blue-grey trees were mostly painted with a single wash of ultramarine and light red to suggest recession.

◁ FARM AT TUDELY

This attractive group is no longer a working farm and the various buildings have been converted into desirable residences. The conversions have been sensitively carried out and, happily, the structures will not now be allowed to fall into disrepair. Inevitably, though, something is lost in the process.

Some of the techniques described in this chapter have been used in this painting. The pond, for example, was simply a liquid wash of pale grey into which darker tones were added, wet in wet, to suggest the soft-edged effect of slightly disturbed reflections. The foreground grass was a broken wash swiftly applied over the rough paper so that specks of white remained to suggest the texture of the surface.

uneven drying, with its attendant difficulties and disasters, results. Light papers of better quality may, of course, be stretched and this treatment prevents cockling however liquid one's technique. The second main shortcoming of cheap paper lies in the quality of its surface, which may accept paint unevenly and unpredictably and fail to produce an attractive surface patina when the washes have dried. Some inexpensive blocks of watercolour paper suffer from the same shortcomings, though to a lesser degree. What, then, is the answer?

I always buy watercolour paper in sheets of Imperial size 30 x 22ins (760 x 560mm). This enables me to work in any size I wish up to that limit; and this in itself has a liberating effect and is much more satisfactory than being tied to the dimensions of a watercolour block or book. I am sure you will find that varying the size of your paintings in this way, according to the type of subject and style of treatment, will enable you to produce more exciting work.

The next question that has to be considered more fully is that of weight. Good watercolour paper is expensive and the heavier it is the more expensive it becomes. The weight is expressed in pounds or grammes per ream and the principal weights are 90lb (185g), 140lb (300g), 200lb (425g), 260lb (555g) and 300lb (640g). Anything below 200lb (425g) needs stretching if an unacceptable degree of cockling is to be avoided, but with the heavier weights the

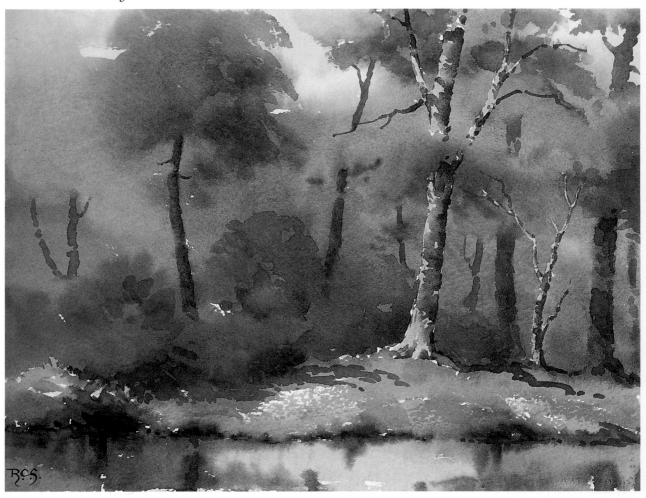

MISTY WOODLAND

Mist has a way of softening outlines and shapes and I decided to emphasise its effect in this woodland scene by applying full washes of tone and colour and allowing them to blend and merge. The dominant colour of the foliage was green, but there were other warmer and cooler colours as well and I rather exaggerated these for the sake of variety and interest. I used masking fluid – a useful aid dealt with in a later chapter – to pick out the crisper shapes of two nearer trees and so provide contrast with the more softly treated background.

amount is negligible. If you decide, for reasons of economy, to use the lighter papers, do not be tempted to save time by omitting the stretching process or you will almost certainly live to regret it. Stretching *is* a chore but it saves time and temper in the long run. This is what you do: first, immerse the paper in clear water for several minutes and then hold it up by two corners to let the surplus water drain off. Lay the wet paper on your drawing-board, carefully expelling any air bubbles between paper and board with a soft cloth. This has to be done with extreme care to avoid damaging the surface of the paper which is

particularly vulnerable when wet. The four edges of the paper are then stuck down to the drawing-board with brown gummed-paper strip (*not* masking tape, which does not adhere to a wet surface). Leave it all to dry overnight and the following morning you should have a flat surface to work on, with the stretched paper as tight as a drum. If through ill luck or lack of proper care you bruised the surface of the wet paper while smoothing away air bubbles, the damaged areas will dry out darker than their surroundings when paint is applied and this will be particularly unfortunate in passages of pale washes, such as the sky. I emphasise the point because it is all too easy for paintings to be ruined in this way.

Watercolour papers come in three types of surface and these are classified according to their degree of roughness or smoothness: smooth (or HP for hot press), intermediate, referred to as 'not' (sometimes CP for cold press) and rough, which is not pressed at all. There are many makes of watercolour paper on the market and although they are normally classified in this manner, they can differ considerably in their appearance and in their handling properties. The best papers are made from pure cotton, with no ad-

mixture of wood pulp, and these are known as 'rag' papers. The best are acid-free and this minimises discoloration and deterioration over the years. There are a few good papers made from wood pulp and these are certainly less expensive. Papers vary, too, in the amount of size used in their manufacture. The greater the amount of size, the harder and less absorbent the surface. Well sized papers stand up better to alteration and the lifting out of colour than do the softer and more absorbent papers containing less size. They also respond better to the use of masking fluid than do their softer counterparts. (The use of resists and masking fluid is dealt with more fully later in the book.)

Makes of watercolour paper also differ in their surface grain, and this of course applies most to the not and rough varieties, where the grain is more apparent. You should avoid papers with a hard, mechanical grain and choose those with a more natural, random surface. Which make of paper and which type of surface you finally choose will depend upon your style of painting and it is worth repeating that careful experimentation and comparison are vital if you are to make the best choice. You will probably find that choice will depend to some extent

(Overleaf) THE TILLINGHAM AT RYE

This painting illustrates the manner in which the surface of the paper (300lb/640g rough) may assist us in achieving the effects we want. The broken outlines of the trees were obtained by using the side of a No 10 brush which deposited pigment on the minute protuberances of the rough surface but missed the little hollows. A similar technique resulted in the broken edge of the horizontal strip of pale, disturbed water by the bend in the river and the rough texture of the grassy banks. A full wash, allowed to penetrate the pores of the paper, produced the smoother effect of the calm water and its reflections, to provide contrast with the rougher treatment elsewhere.

BOATHOUSE, DERWENTWATER

I used a not paper for this peaceful Lakeland scene. A good paper possesses a surface patina which becomes apparent when some granulation occurs as the washes dry. Here the ultramarine used in the grey of the cloud shadows and the distant mountain has produced just such an effect.

The soft reflections in the water were obtained by dropping deeper colour into a still wet wash of pale grey – the wet in wet technique in which timing and judgement are all important. The full, liquid washes used in this painting helped to preserve its freshness and clarity.

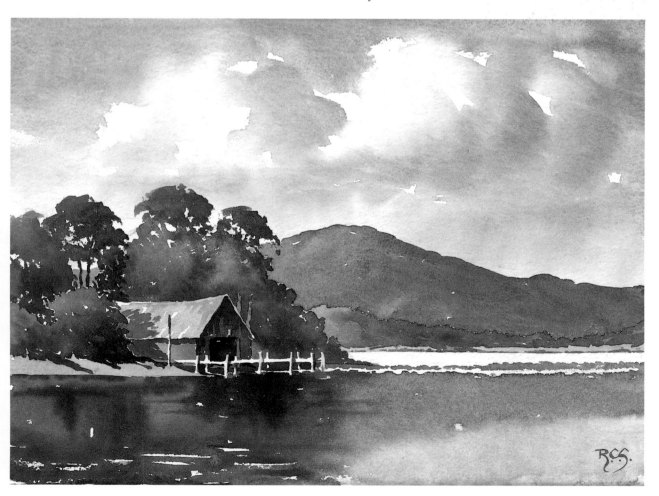

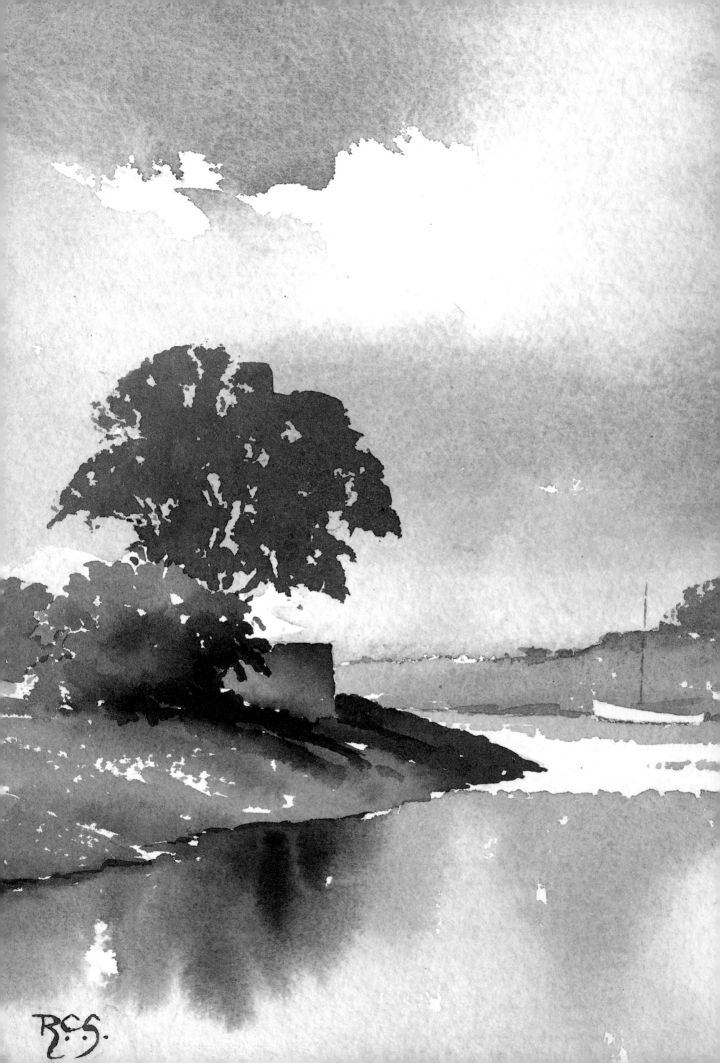

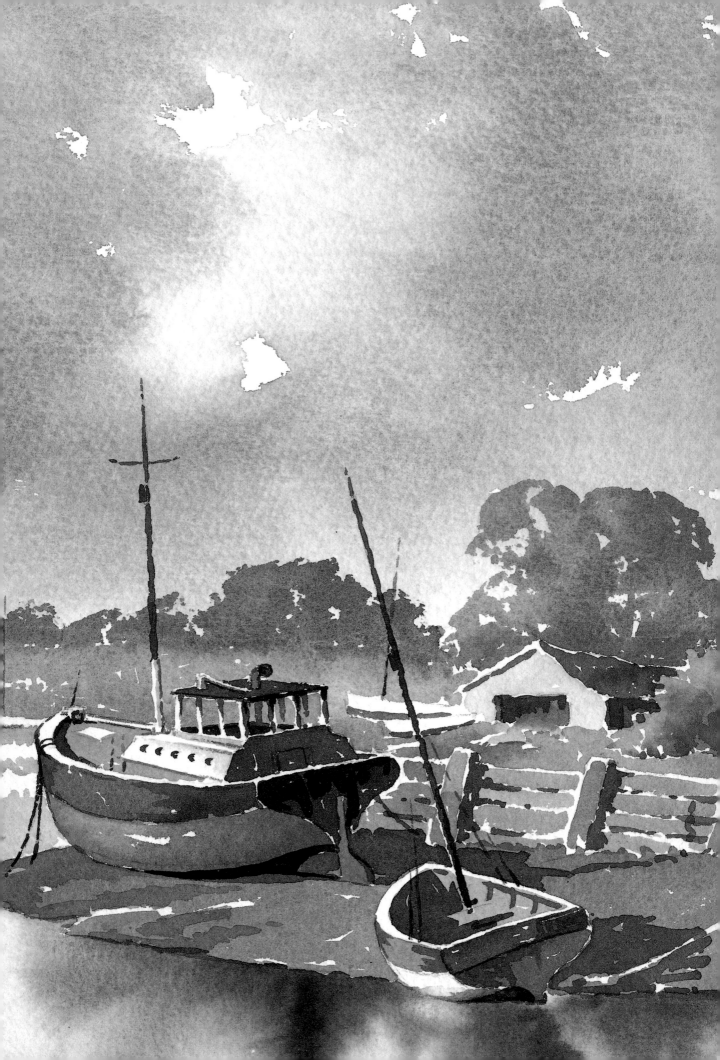

upon subject matter and that you will end up, as I do, using several different makes of paper and both not and rough surfaces. Smooth paper is, on the whole, less suitable for most styles of watercolour painting, though its smoothness makes it useful for very detailed work and I have seen it put to good effect for capturing serene maritime subjects with full, horizontal washes used to build up telling impressions of calm water. At the other extreme, a rough, grained paper assists greatly in broken wash and dry brush techniques and these topics are dealt with in some detail in a later chapter. Some colours, notably ultramarine and some of the earth colours, granulate in use, with little concentrations of colour settling into the minute indentations of the paper, and this phenomenon can be put to good and effective use to represent various surfaces and textures. Granulation is naturally most apparent on rough papers, but there is some variation between different makes and this is another characteristic that should be taken into account when choosing papers.

When you have finally decided which papers do most for your particular style of painting, it is well worth sticking to them and getting to known them really well, for this helps to eliminate the problems of unpredictability. Getting to know how papers react is half the battle.

Examples of some of the effects I have mentioned are shown below.

Watercolour paints come in two qualities – Artists' and Students'. The artists' quality undoubtedly has greater strength and clarity, resulting from its more finely ground pigments, but students' quality paints have improved in recent years and the better makes are quite acceptable. I prefer the greater power and purity of the artists' quality and although they are considerably more expensive, they are economical in use – a little paint will produce a full liquid wash – and as watercolourists we surely need all the help we can get from our materials. There are a number of reputable manufacturers, all producing excellent paints, but colours and to some extent handling properties differ from make to make and I believe it is good sense to stick to one and become really familiar with it. For a similar reason a limited palette helps you to get to know the properties of a narrow range

Key:
1. Overlapping washes on smooth (HP) paper.

2. A broken wash on rough paper. Notice how the brush leaves chains of white dots where depressions in the paper remain untouched – useful for describing quickly and boldly certain types of surface.

3. An example of granulation, showing how little concentrations of pigment may settle in the surface depressions of a rough paper – the reverse of the broken wash effect.

4. Dry brush work. Here a brush containing a limited wash is dragged over a rough surface to produce a ragged effect – useful for broken forms such as foliage.

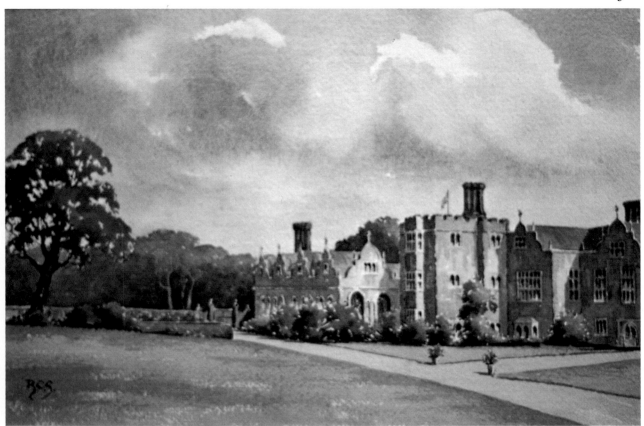

of colours really well, and has the important additional advantage of helping your paintings to 'hang together'.

To my mind, watercolour is at its best when used as a transparent medium, without body colour, and transparency is a quality we expect in good quality paint, a topic we will investigate more fully in the next chapter. For now suffice it to say that your choice of colours – your personal palette – will say something about the way you see your subject matter and will constitute one facet of your style of painting.

Paints come in pans and in tubes. My own practice is to use a small folding watercolour box containing pans of my favourite colours and top these up with tube colour whenever I am about to start a new painting. In this way I always have fresh colour at my disposal and there is not the waste which results from squeezing blobs of colour onto a palette which is washed after each painting session.

Style in watercolour depends fundamentally upon brushwork and really good brushwork is almost impossible with inferior brushes. Once again I fear I am advocating expenditure upon expensive products, but anything else is false economy. It is well known that the best watercolour brushes are made from red sable hair and today these are exceedingly expensive. Those lucky enough to possess a stock of sable

THE WEST FRONT, KNOLE HOUSE

This watercolour was a commission for Lord and Lady Sackville and it was a pleasure to paint a small part of this magnificent mansion, with its 7 courtyards, 52 staircases and 365 rooms. Although its appearance is Tudor, parts of it are very much older.

It was important to choose a time of day when the sun would be in the right position to illuminate some elevations and cast shadows on others, in order to emphasise the form of the west front. The use of light and shade in this way helps to produce a three dimensional effect.

The large tree on the left, the deep-toned woods beyond and the grey clouds above all help to balance the weight of the building on the right. The suggestion of texture in the foreground grass was achieved by the swift application, with a large brush, of a full, horizontal wash.

brushes treat them with the greatest care to ensure that they continue to give good service into the future. Those less lucky are usually forced to look for alternatives, and there are a number of these, notably squirrel hair, ox hair and a variety of synthetics. In the mid 1980s a well-known firm of artists' colourmen developed a brush which comprised a blend of synthetic fibre and red sable hair. The inclusion of sable resulted in a brush that holds washes well, comes to a good point and possesses satisfactory spring. I was recently asked to test four alternative developments to this range for the same manufacturers and found all four excellent and one outstanding. I believe it will shortly go into production and will offer something very nearly as good as the real thing.

Proper care of brushes will greatly prolong their useful life. Always wash them thoroughly but gently in clear water after use and shape up their points with your fingertips while they are still damp.

Do not put them in an airtight container while they are still moist, for this slows the drying process. Similarly, it is not good practice to stand them in a jar while they are still wet, as the residual moisture will run down the hairs to the ferrule opening and over a period this will also cause damage.

Make sure that you have plenty of space for mixing your washes. The depressions in the lids of paintboxes are rarely adequate and need supplementing. There are many mixing palettes on the market, but white kitchen plates and saucers are as good as anything.

A light easel for use on location will be necessary unless you prefer to work with your board on your knee, as I usually do, and a light folding stool is another useful accessory. Watertight screw-top jars for holding water, plenty of rag or tissue, pencils, soft erasers and a haversack for carrying it all in complete the list.

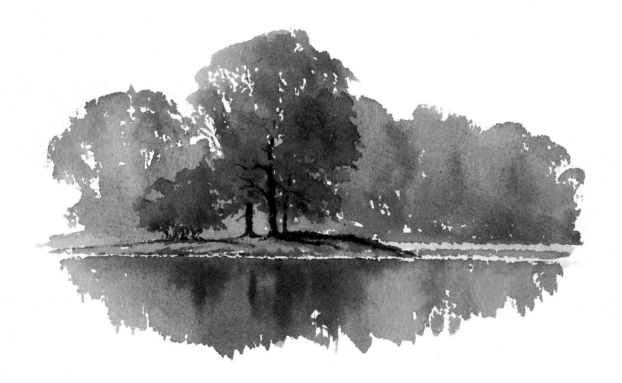

Chapter 2

COLOUR AND STYLE

I once asked a number of my students to paint, as rapidly as possible, a group of farm buildings in the Weald of Kent, and to concentrate on colour rather than form. It was a brilliant morning and the strong sunlight brought out the rich colours of the scene – the glowing reds and browns of old brick and tile and the strong yellows and greens of the surrounding foliage. Most of the results were fresh and lively and all were colourful, but what I found of par-

LES TOITS DE LA ROQUE
I made this quick watercolour sketch from the bathroom window of a holiday house in the Provençal hill village of La Roque. I was attracted by the unplanned jumble of Roman-tiled roofs with their predominantly horizontal format, relieved by the dark verticals of the cypress trees and the belfry of the little church. I was attracted, too, by the rich colours of the roof tiles, the sunlit walls and, not least, by the deep but subtle colours in the shadows, with their suggestion of warm reflected light.

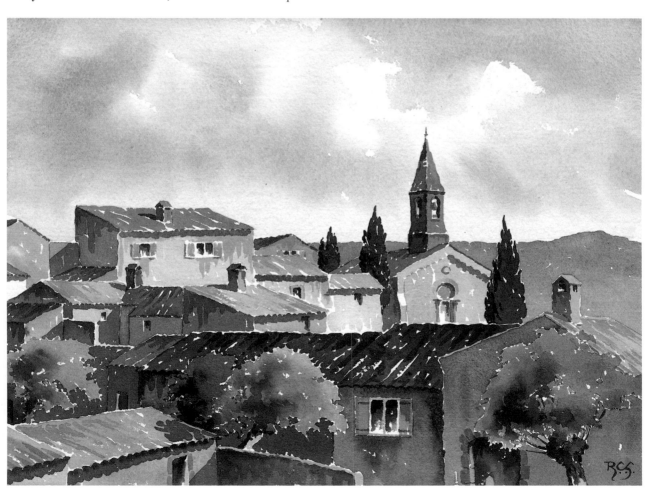

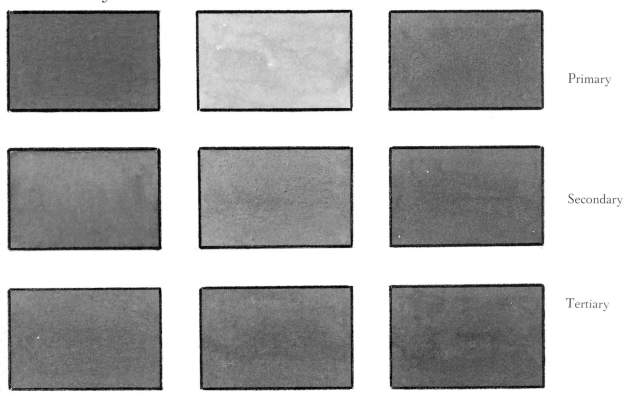

Primary

Secondary

Tertiary

ticular interest was the colour variation between one painting and another, illustrating the fact that we all see colour differently and respond to it in different ways. Most painters have an aesthetic appreciation of the colour in the scene before them, and some have a natural response to it and the ability to reproduce it faithfully in paint.

Colour plays such an important part in most styles of painting that it behoves us to understand at least something of the fundamentals of colour theory. As every student knows, there are three primary colours, red, yellow and blue. The simplest palette must contain at least one variety of each if a full range of secondary and tertiary colour is to be obtained. The secondary colours are each made up of two primaries – red and yellow to make orange, red and blue to make violet, and blue and yellow to make green. When some of the third primary or another secondary colour is added, the resultant mix will be a tertiary colour (or a broken colour, as it is sometimes called). Tertiary colours can be delicate and elusive, rich and strong, or something in between, but whatever their tone, they can add interest and subtlety to a painting.

Watercolourists in particular have to be constantly on their guard against mixing too many colours together, for it is all too easy for muddiness to creep in and destroy the essential attributes of watercolours – their clarity and freshness. This can so easily happen towards the end of a painting

session when more pigment is added to mixtures already on the palette. It is sometimes tempting to modify and adapt an existing mix of doubtful parentage but it is usually safer to start again from scratch if dull and opaque effects are to be avoided.

Watercolourists rarely include the three primary colours in the purest form obtainable in their palettes and usually opt for some variation of each. In my own limited palette, my red is light red, my yellow is raw sienna and my blues are ultramarine and Winsor blue. Because both light red and raw sienna contain some brown, the secondary colours that result are not pure orange, green or violet, but something more subdued, of greater subtlety and hence of more

RIO DEI GRECI

This Venetian canal has long been a favourite with artists, as much for its colour as for its form. Here the warm evening light imparts a rich glow to the ochres and terracottas that abound. These give way to a soft purplish grey as they recede into the distance and this 'greying' reinforces perspective to create a feeling of recession. The nearer buildings on the left are painted in stronger tones to make them come forward. There were in fact many more mooring poles in the foreground but all but two were sacrificed to avoid over-complicating the composition.

The sky was a graded wash of pale raw sienna, with a little light red added towards the horizon. Ultramarine was the only other colour used and this limited palette helped to give the painting a feeling of unity.

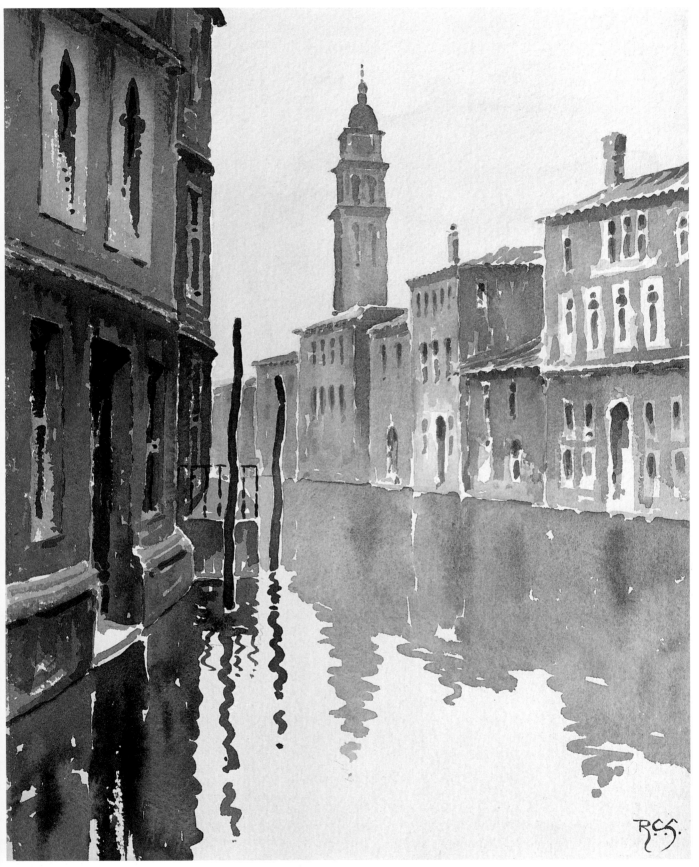

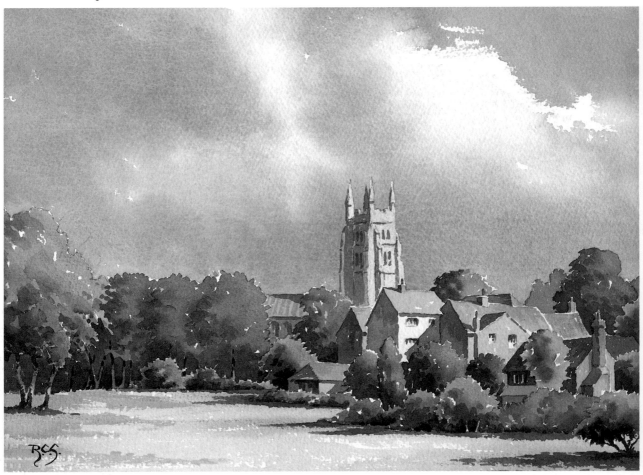

relevance to landscape painting. In this book we are concerned with landscape and marine painting and so do not require the much brighter palette which would be needed, for example, for flower painting.

The most effective way of making a passage appear to shine is to use a very pale transparent wash and then place some really deep-toned colour next to it. This method of indicating strong tonal contrast is a fundamental ingredient of successful painting and one should be constantly on the look-out for opportunities of placing lights against darks and darks against lights. In much the same way a particular colour in a painting can be emphasised by placing a complementary colour beside it. Complementary colours are, quite simply, pairs of opposites, for example red and green, blue and orange, yellow and violet. One frequently sees landscape paintings with trees, bushes, hedges and grass all in varying shades of green with just one small figure in bright red. The fact that the figure is surrounded by a sea of green makes the red appear much stronger and brighter than would otherwise be the case and so provides a telling accent.

Colours may also be classified according to their 'temperature'. The hot colours are the reds, oranges

TENTERDEN CHURCH

There is a variety of building material in this attractive group – ragstone, brick, white weather-board, tile and slate – and a corresponding variety of colour. There is plenty of colour, too, in the early autumn foliage and I emphasised the difference in greens between trees of various species. Even if there is in fact very little colour variation in the foliage, it is important to make the most of what there is to provide interest.

The sunlit side of the church tower was preserved with masking fluid and this enabled me to establish a bold, liquid sky without having to paint carefully round a complex shape.

DOCKSIDE ROAD ▷

This is a development of a demonstration painting from my book, *Fresh Watercolour*. It is all about colour – the murky but warm tones of a foggy London twilight – and light, albeit of the artificial variety. It is also an exercise in the use of the limited palette, for only three colours were used – ultramarine, light red and raw sienna in various combinations. This not only helped to suggest atmosphere but gave the painting a feeling of unity, enabling it to 'hang together'. My main preoccupation was to capture the effect of the radiance round the street lights, with the aid of controlled washes, and to preserve the pale tones of the lighted windows and their reflections.

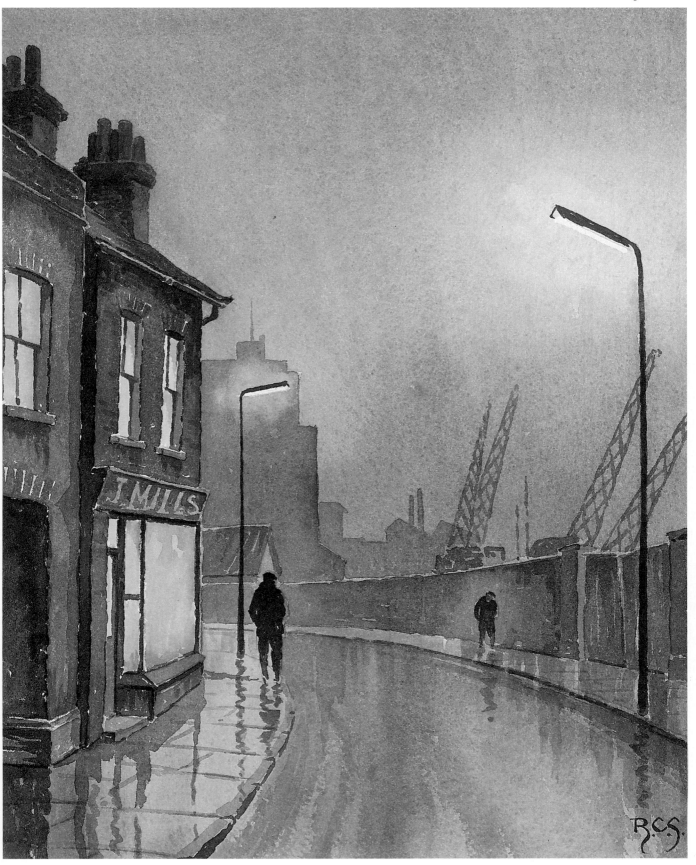

and yellows and the cools the blues and the greys, with a host of intermediate colours of varying temperature in between. The hot colours appear to come forward in your painting and the cools to recede and this is, of course, what one sees in nature. Distant hills are usually bluey-grey and this is how they should be painted. The foreground, on the other hand, appears much warmer, so use some hot colours here to make it come forward. In this way a feeling of recession is achieved. Of course the situation is not always as simple as it seems – little in art ever is – and there are instances where the general rule does not seem to hold good. On a cloudless day, for example, the blue of the sky may strongly influence the colour of foreground shadows, which may appear quite cool. In very clear conditions distant fields of ripe corn or ploughland can look very warm in tone and quite unaffected by the cooling, greying effect of distance. This presents a problem, for if we make them look too warm, the feeling of recession, which we are trying to create, will be destroyed. We have, therefore, to compromise with the truth and introduce just a little greying to give the impression of distance.

The question now arises as to how the use of col-our may influence style. In this context the development of style should not be a conscious objective or an end in itself, but rather a subconscious by-product of using one's powers of observation and imagination. A vital part of the creative process is just looking, hard and analytically, at the subject. If we do not use our eyes in this way, our colours will in all probability be flat, conventional and uninteresting. We have all seen paintings of trees in which the foliage has been painted an even, unrelieved green and even the areas of shadow have been represented simply by a darker version of the same green. If the painter had

SOAR MILL COVE, DEVON

This little bay is typical of the many attractive inlets in Devon's rugged coastline and provides a harmonious study in grey and green. The dark tones of the rocky cliffs provide an effective contrast to the paler tones of the sea; the foam and surf are simply the white of the paper. The foreground section of cliff on the left and the rocky island above it balance the headland on the right. The line of wet reflecting sand, the flotsam line below it and the shoreward movement of the waves all draw attention to the two small figures on the beach. The red shirt also claims our attention – an example of the use of complementary colour.

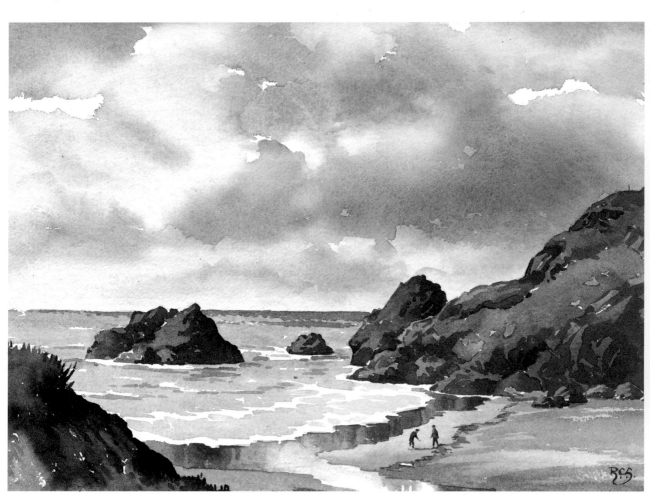

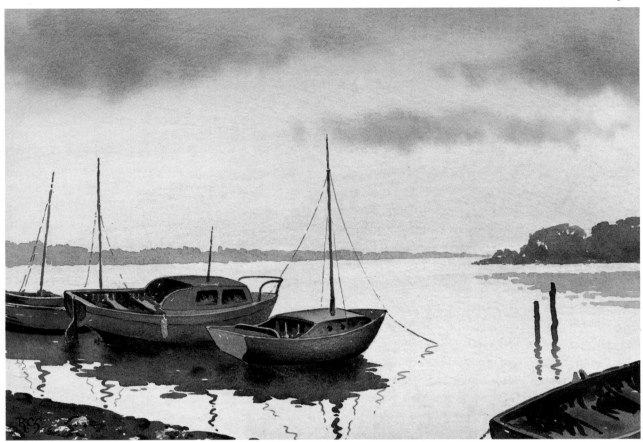

looked more searchingly at his subject he would probably have discovered areas in which the green was modified a little by yellows, oranges and browns and others where the shadows contained hints of blue or purple. These deviations from the overall green may be very minor ones, not easy to spot, but they are nearly always there and, if incorporated into the painting, will add enormously to its interest. If we use our imaginations, we may well emphasise these elusive colours, and this too, will give the work greater impact. It is the job of the artist to do better than merely reproduce superficially and uncritically, to look under the surface and, perhaps by some degree of emphasis or even exaggeration, to say in colour what he feels about his subject.

EVENING LIGHT

Watercolour is a delicate medium and is at its best when used with restraint and discrimination. It is usually fatal to attempt to reproduce literally the lurid colours of the more spectacular type of sunset and far more satisfactory effects can be obtained through subtlety and understatement. The colour in this evening sky was in fact considerably stronger than I have shown it but any attempt to reproduce its brilliant pinks and oranges would have produced a harsh and garish result. The deep tones of the boats and their reflections contrast with the pale variegated wash and make the water appear to shine.

ON CHOOSING AND COMPOSING SUBJECTS

Those who enjoy painting are rarely at a loss for subject matter and their problem is often to choose between the competing alternatives before them. Unfortunately the inexperienced do not always choose wisely and sometimes their ambition outruns their ability, with disappointment and frustration the inevitable consequence. This sad state of affairs usually results from tackling subjects of excessive complexity and difficulty. Grand panoramas containing a vast amount of detail may well have great visual appeal but rarely make satisfactory subjects for those of limited experience. It is all too easy for them to get bogged down in that mass of detail and for the resultant over-working to rob their ef-

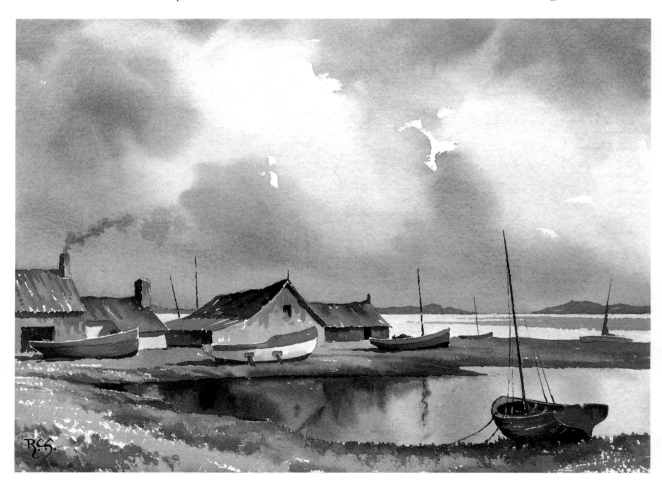

forts of all freshness and clarity. This applies with particular force to watercolour, a medium ideally suited to capturing atmosphere and feeling but usually less effective when used for meticulous and repetitive detail. With growing experience we begin to recognise subjects that will respond well to watercolour and to our style of using it, and reject those which, however superficially attractive, are less suited to the medium. So be content, at least in the early stages, to choose something relatively simple to paint. Instead of an extensive and complicated landscape, try the view through a farm gate with just a field and a bank of trees beyond. The distant trees

◁ FISHERMEN'S HUTS, BRANCASTER STAITHE

The unplanned jumble of whelk sheds and fishermen's huts provides the subject of this marine painting. Although rather strung out in a line for perfect composition, they do overlap to some extent and so relate to one another. They have been painted strongly to enable them to register effectively against the warm evening sky and its pale reflection in the water below and they are balanced by the deep-toned dinghy in the right foreground. The half-dozen masts provide useful vertical foils for the predominantly horizontal lines of the painting.

could be suggested by a plain wash of grey/green and the grass of the field kept simple and pale in tone, enabling you to concentrate on the weathered wood of the gate and the rough grass on either side of it. Without a mass of extraneous matter to overwhelm you, you can give the foreground features your full attention and perhaps capture something of their texture and character.

It is generally acknowledged that sound drawing is the basis of all good art, and however accomplished the painting technique, the end result can never be better than the underlying draughtsmanship. Some folk are so keen to make a start on their painting that drawing and composition receive scant attention. As a result their subject may be poorly observed and badly arranged on their paper. It is much better to spend more time studying the chosen subject in some depth and making several exploratory sketches from varying viewpoints. This will not only enable you to look under the surface of your subject matter and analyse it more fully but will help you to decide on the most promising vantage point and the manner in which the subject should be arranged on the paper – in other words its composition.

In your initial sketches always bear in mind that

negative shapes – the spaces between the various features of your subject – have just as much compositional significance as the features themselves and merit equal consideration. When you are making these quick sketches, keep your lines light and exploratory, gradually strengthening those that appear correct and ignoring the others. Nothing is more inhibiting than a hard, uncompromising outline that turns out to be incorrect.

Once you have completed this exploratory stage and have worked out your preferred composition, both mentally and on your paper, you are in a position to transfer it to your watercolour paper, using as few lines as possible.

Most painters enjoy landscape work for there is something about the countryside that strikes a chord in all of us. But love of the rural scene should not blind us to the wealth of subject matter in our towns and cities. I am particularly attracted to urban subjects at dusk, when a warm light may pervade the scene and lights begin to appear at house and shop windows. Foggy conditions can add greatly to the mood of subjects such as this and watercolour is ideally suited to capturing its atmospheric effects. It is admittedly not easy to paint in the open in such conditions, but a quick Conté impression or two in one's sketch-book and perhaps a few colour notes may

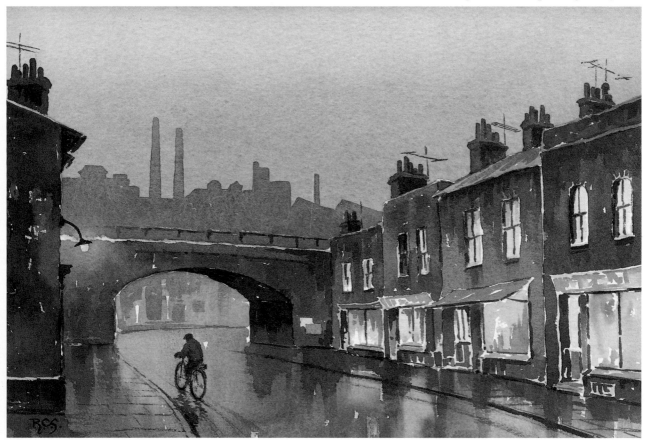

well be a sufficient basis for a studio painting, particularly if tackled promptly, before the visual image starts to fade.

Finding pleasing compositions in built-up areas sometimes presents a problem but, with patience and perseverance, they *are* to be found. I once made a number of quick sketches of groups of older city buildings in the South London area from the vantage point of a train trundling along an embankment at roof-top level during a fog service. Occasionally the train would be held up by a signal at some ideal spot, but more often the sketches had to be of the lightning variety. Such everyday material as pylons, dockside cranes and even telegraph poles can play their part, especially when seen in silhouette against an evening sky.

Dull, grey tarmac roads are not normally very appealing subjects for the artist, but if painted when wet from a recent shower they can be transformed by the reflections of illuminated windows, neon signs, and street lights, and present an altogether more interesting appearance. Dockside areas can be rich in character and atmosphere and are well worth exploring. The coastal scene, too, will provide a rich harvest of subject matter, and boat-yards, with their characteristic nautical clutter, can usually be relied upon to furnish a wealth of fascinating possibilities.

THE RAILWAY VIADUCT

There is nothing inherently attractive about this *Coronation Street* type of subject and painters who are attracted only by the rural scene and the unspoiled countryside would not even consider it. But inner city back streets have an appeal of their own if they are tackled with imagination and understanding. The quality of the light can play an important part and a warm, misty twilight can impart a touch of magic to an otherwise drab scene. I made full use here of the illuminated shop windows and their reflections while the figure of the solitary cyclist, silhouetted against a pale patch of roadway, adds a hint of drama.

Only three colours were used in this painting – raw sienna, light red and ultramarine.

The opportunities are endless and the answer is to develop a responsive eye that will spot likely subject matter in the most unlikely places, and to tackle it boldly and with style.

We now come to the tricky subject of composition and, as we have already noted, even a brilliant painting technique cannot mask weaknesses in arrangement and balance. Composition is a difficult matter to define. We recognise good composition because there is a harmony and a sense of design about well composed paintings that we find satisfying and attractive. In some books on drawing and painting the

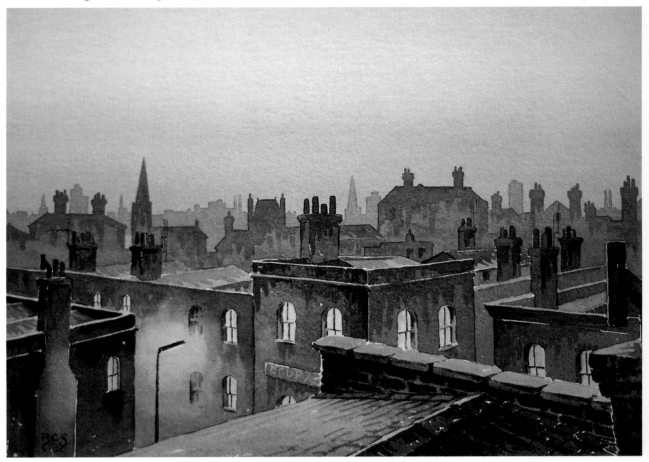

LONDON ROOFSCAPE

It sometimes pays to find an unusual angle, to give a mundane subject an original slant. This view of Victorian buildings in one of the older districts of south London was painted at roof-top level as day was fading and lights were beginning to appear in house windows. I began with a variegated wash of raw sienna, warmed with light red above the horizon. The pale grey silhouette of the most distant buildings went in next (ultramarine and light red) and ever stronger mixes of the same two colours served for the nearer buildings.

Care was taken to preserve the arc of radiance round the street light and only in the foreground building was any attempt made to indicate individual bricks and slates.

subject is dealt with analytically and almost geometrically, implying a rigidity that has no place in art. For the average painter this approach may create more problems than it solves. I have always found it best to warn my students against the sort of errors most commonly encountered and to remind them that a well composed painting will present a pleasing design. If you emphasise the main construction lines of your sketch and then add broad areas of tone, an abstract pattern will emerge which may be well balanced and pleasing or the reverse. If the latter, that is the time to have another go with the object of developing something rather more aesthetically satisfying.

There are a number of things to avoid in composing a painting and it is helpful if these can be kept constantly in mind. Some of them are obvious and well understood but they are nevertheless worth restating. You should, for example, avoid placing a dominant feature such as a church spire exactly halfway between the left- and right-hand margins of your paper. For much the same reason you should avoid placing a strong horizontal, the horizon for instance, exactly halfway between the top and bottom of your paper. Try to arrange your objects in groups so that they overlap and relate to one another, and do

not string them out in a straight line. Avoid allowing unrelated lines to coincide – a roof apex of a building exactly in line with the horizon would be an example of this. It is always a good plan to give your work a centre of interest to which the eye is encouraged to travel and come to rest, perhaps helped on its way by the skilful placement of other lines in the composition – a line of hedge or a track leading towards your focal point, for example.

It is fatal for a painting to contain two competing centres of interest, for the eye of the viewer will move from one to the other and find nowhere to come to rest. Strongly marked lines (such as road margins) exactly emanating from one corner of the paper are also best avoided.

The danger is that such a string of negatives may result in the production of safe but tame and conventional compositions and this can be as bad as breaking a few rules. But this need not be so and it is up to the artist to experiment with different viewpoints and arrangements and to discover one that is both pleasing and original. The manner in which artists solve the problems of composition are both diverse and individual and so form an integral part of their styles.

The analytical study of the works of the masters will show you how they resolved their compositional problems and this will help you enormously in your own work.

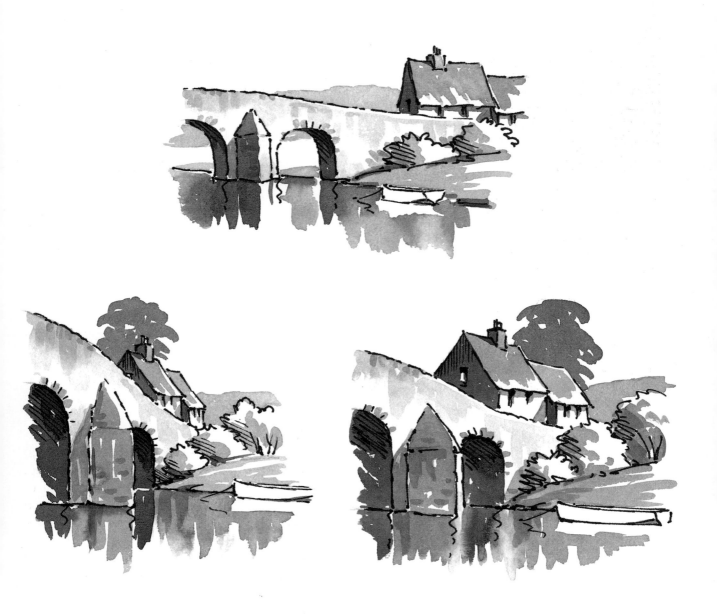

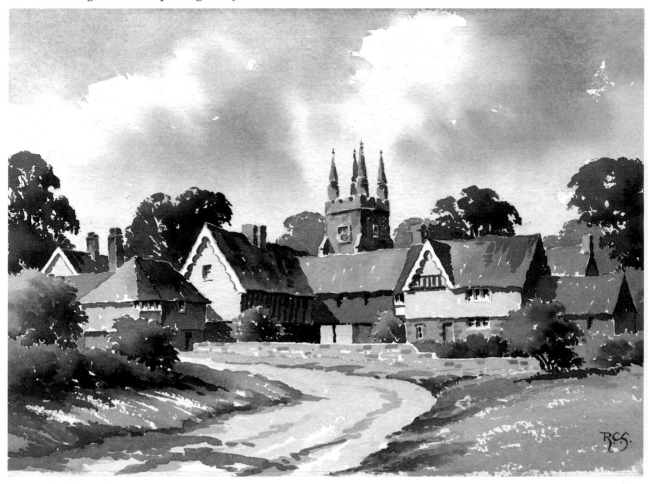

OLD HOUSES AT PENSHURST

One sometimes comes across a subject that provides a natural composition and needs no artistic 'improvement'. This jumble of old houses clustering round the mediaeval church tower comes close to that ideal although even here some modification had to be made, namely the elimination of a driveway forking right from the bend in the road. Forking roads are notorious for destroying compositional harmony. As it is, the eye follows the curving road to the left hand building and then travels along the line of buildings to the church tower and the glimpse of sunlit churchyard below it. The church tower is, perhaps, rather too central for comfort and the inclusion of more detail on the left would have been an improvement.

(Opposite, above) WHELK SHEDS, BRANCASTER STAITHE

A closer view of some of the tumbledown buildings on this stretch of Norfolk coast. Their jumbled shapes against a marine background provide an appealing subject while the tarred felt, rusty corrugated iron and old brick of their construction are a source of rich colour. The strong lateral light creates a series of cast shadows which help to link the various elements together.

This is not a perfect composition for there is nothing to prevent the eye sliding off the painting to the left, assisted by the strongly directional line of the fore-ground boat. A larger sheet of paper would have enabled me to include the strong lines of a moored fishing boat and this would have provided better balance.

(Opposite, below) NORFOLK BOATYARD

This small repair yard lies behind the ship-chandler's at Burnham Overy Staithe and today is more concerned with pleasure boats than it is with traditional fishing craft, although some solid wooden shapes are still to be seen. Like most boat-yards it is rich in subject matter and the problem was to choose between the many possibilities on offer. I liked the grouping of the boats in this composition, the manner in which the lateral shadows seemed to link the various elements together and the way the trees on the right balanced the buildings on the left. This created an interesting pattern with plenty of tonal contrast.

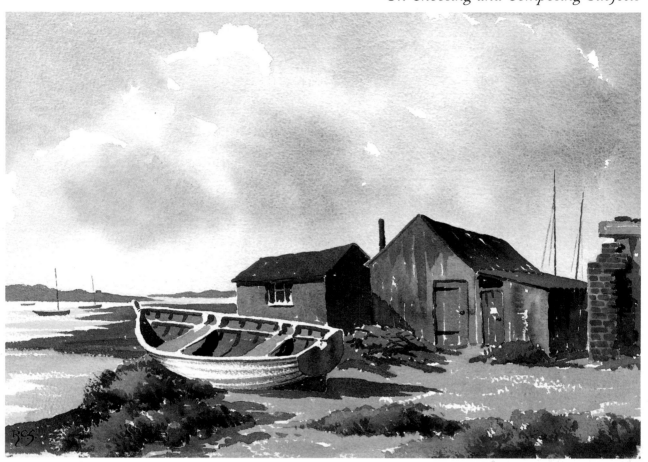

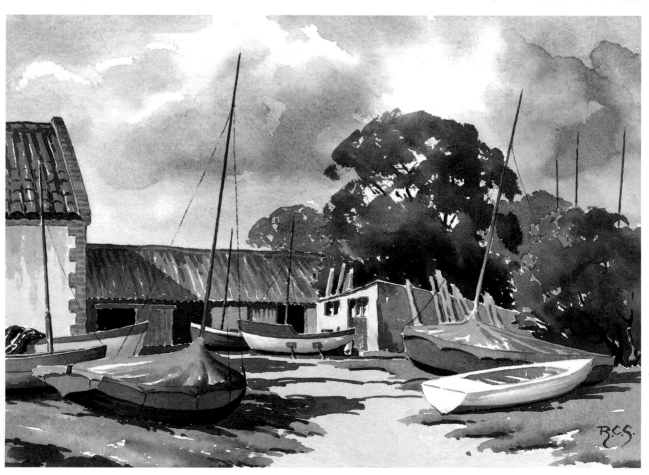

DEMONSTRATION 1

FISHERMAN'S HUT, WALBERSWICK

Buildings come in all shapes and sizes and it is sometimes the most ramshackle that make the most appealing subjects. This old hut looks as though it was built of driftwood and is a case in point. It was painted loosely, with no attempt to tidy it up, but plenty of colour was used on its shadowed side, including strong burnt sienna for the rust stains. The sheds beyond were painted with decreasing definition, to suggest recession. The near hut, its strong reflection and the beached boat are balanced to some extent by the mass of dark cloud on the right.

Stage 1

To aid reproduction I have made the pencil lines much firmer and stronger than I normally do, and this applies to the other demonstrations later in the book. As your confidence increases you will be able to manage with less and less pencil and this will liberate your brushwork and help to develop your style. Tricky objects, such as boats, will still require careful drawing and the placement of the main elements in the composition will still need establishing, to ensure balance, but the outlines of trees, distant hills and the like may be safely left to the expressive strokes of the brush.

In Stage 1 I simply established the sky, using three large brushes and three full washes of (1) palest raw sienna for the sunlit clouds, (2) ultramarine and light red for their shadows and (3) ultramarine with a little Payne's grey for the blue of the sky. I allowed these washes to blend, to produce soft gradations of colour and tone, but preserved a few hard edges to give the pale area of cloud some definition.

Stage 2

I added a second wash of grey to the cloud shadow on the right, blending it into the lighter areas of the first wash with pure water but leaving a few hard edges. The resulting deeper tone helped to balance the main weight of the painting on the left. The water went in next, with broken horizontal strokes of palest grey in the distance – ultramarine with a touch of light red – merging into a pale green in the foreground. A few vertical and horizontal strokes, painted wet in wet, suggested the soft reflections of the cloud shadows in the foreground water. The trees and the line of distant hills were established with single washes of a deeper grey, plus a touch of green to provide variety. The distant hut and its spit of land were in shadow so a still deeper tone of the same grey was used, with a little light red added to suggest the warm colour of the roof tiles. The middle-distance hut was painted with greater tonal and colour contrast and the area of scrubby grass was given an initial overall wash of pale raw sienna and Payne's grey, varied here and there with a little warm and cool local colour.

Stage 3 (Overleaf)

It only remained to paint the main hut, the beached boat, the little landing-stage and the reflections in the water, and then add shadows and texture to the foreground grass. Strong tonal contrast brought the hut forward and helped it to stand out bodly against its background. The shadowed side of the roof, a strong wash of light red and ultramarine, registers strongly against the pale sky, and the hut supports, in deepest shadow, contrast with the pale khaki-coloured grass behind. The treatment was kept loose and bold to help suggest the roughness of the construction materials.

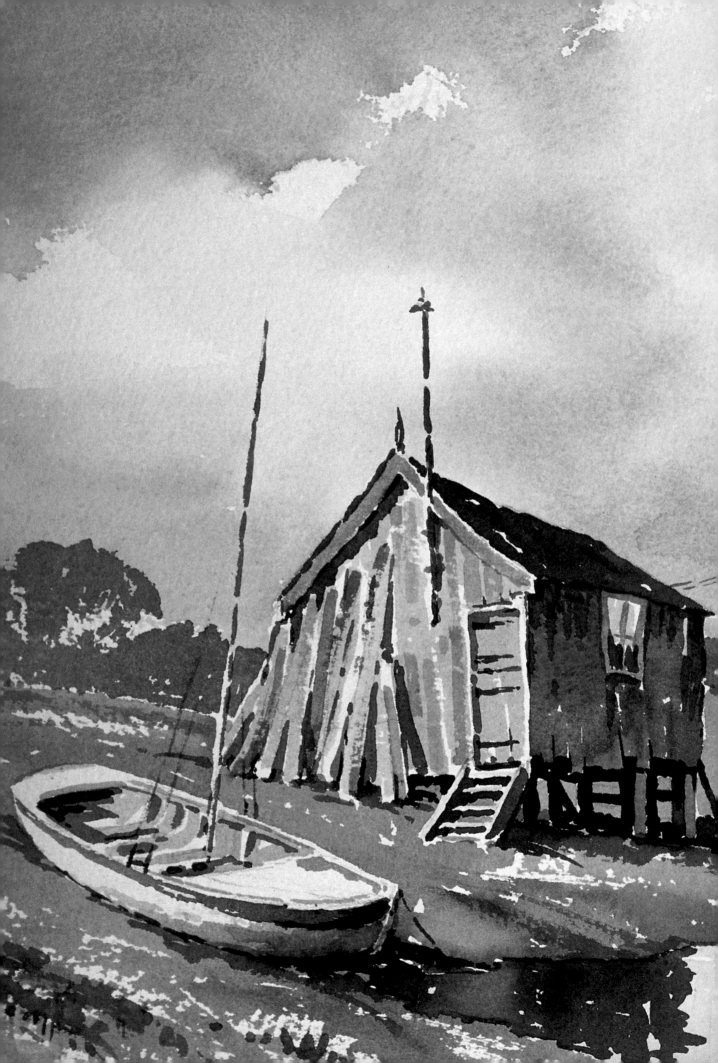

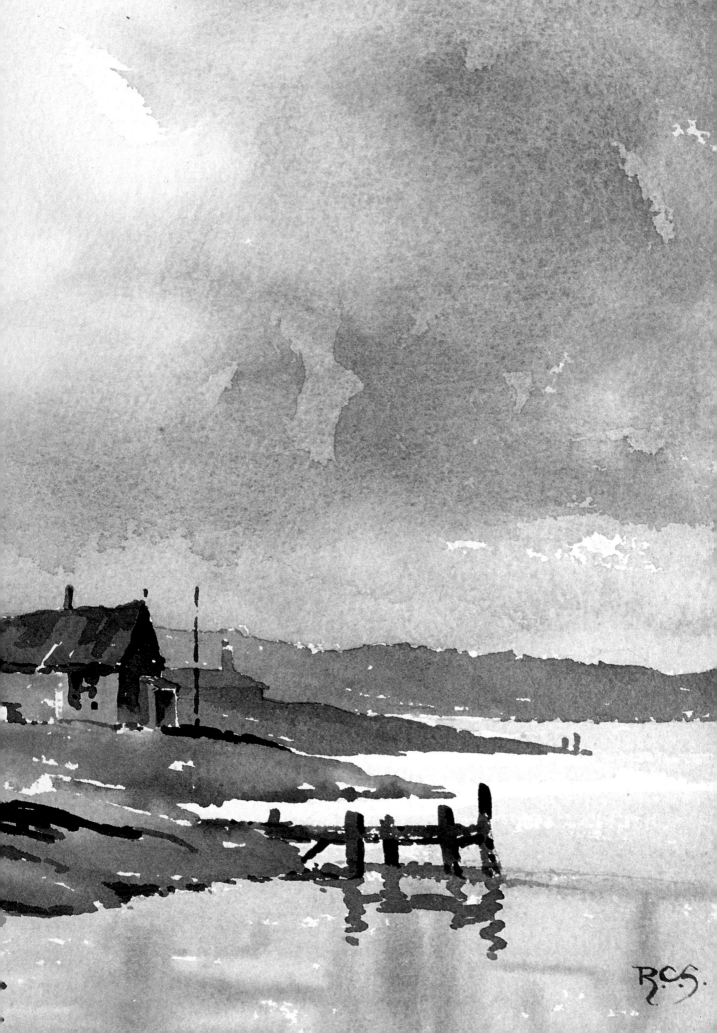

Chapter 4

ON LOOSENING UP

As I suggested earlier, timidity and fear of making mistakes are two of the main obstacles to developing a fluent and painterly style; so ignore your inhibitions and fears and go about your painting with zest and panache. True, this is easier said than done, particularly for those with a naturally meticulous style, but it is well worth the effort. Fluency in painting is not the exclusive prerogative of the bold, impressionistic cast of painter and there is no reason why those with a more precise approach should not acquire it. It is largely a matter of brushwork. A further obstacle to achieving fluency and style frequently lies in the manner in which the preliminary drawing is made. If this is too precise and complete, the painting process simply becomes a matter of filling in pre-drawn shapes, as we have already noted. The amount of preliminary drawing done is a matter of personal taste and must, of course, depend

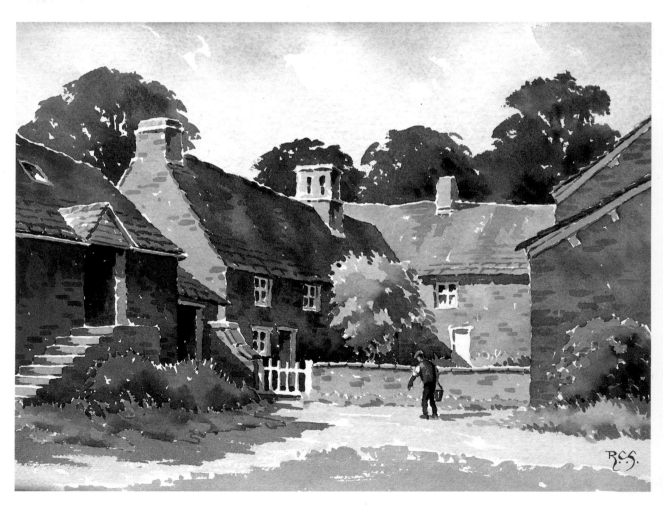

MORNING RIDE

I had intended to make a quick, atmospheric study of a stretch of deserted foreshore when these two riders appeared. They not only served to provide a focal point but their small figures, in dark silhouette, somehow accentuated the impression of empty space. I made the most of the areas of wet, shining sand by using deeper tones for the adjacent dry sand. The sea was loosely suggested, with only the nearest wave being given any prominence. The cloud shadows on the right help to balance the riders and the area of dark sand below.

◁ COTSWOLD FARMYARD

A loose style of painting is especially suitable for capturing the rough stonework of old buildings and has the added advantage of enabling you to work more quickly. In this painting the small area of sky was kept very simple with pale washes of Winsor blue and raw sienna. The background trees were flat washes of stronger colour with still deeper colour dropped in, wet in wet, to denote shadow. They play an important part in providing tonal contrast with the much paler stone-slated roof and chimneys. Notice the marked contrast in tone between the sunlit and shadowed elevations of the buildings and the way in which their material has been suggested by the painting of a few random blocks of stone. The white gate, which registers boldly against the shadowed area behind, was preserved with masking fluid. The small tree in the centre also provides tonal contrast.

to a large extent upon the subject matter. A complicated composition of jumbled buildings, for example, would certainly call for careful drawing if perspective were not to suffer, but even here a rough indication of the main construction lines is all that is really needed if brushwork is to be liberated from the prison of a rigid framework.

There are, of course, certain subjects which, by virtue of their complex shapes, demand reasonably careful drawing. Boats are a case in point and, incorrectly drawn, can look most unconvincing. The curved arches of bridges are another common source of difficulty and it is unwise to begin painting until you have really mastered their shape in pencil. Despite a few special cases, however, it is still better to limit the amount of your preliminary drawing as strictly as you can. Some landscape subjects, consisting mainly of a few trees and fields, may need no more drawing than, perhaps, a brief indication of the position of the horizon. If the outline of your foliage masses do not conform exactly to what is on the ground, what does it matter provided they are painted loosely, convincingly and with style? I have seen students painstakingly outline in pencil the ragged outlines of trees in full leaf prior to filling the complex shape with green pigment. The results, as one would expect, were tight and quite unnatural.

On Loosening Up

How much better to let a brush wielded with skill and conviction do the work!

Skill with the brush rarely comes automatically, and if brushwork is to improve, you have to work at it. This need not necessarily mean subjecting yourself to a series of boring exercises, useful though these can be, provided you school yourself to use brushes loosely and freely in the course of normal work. In the early stages there will be many failures and you will be tempted to revert to your previous methods. But if you have the courage of your convictions, you will have the satisfaction of seeing your brushwork improve and your style develop.

Here are two examples of some tightly painted objects, on the left, with suggestions for a freer treatment on the right.

The way you hold your brush may well have some bearing on your results. If you hold it as you would a pen you achieve control if not fluency. Held between thumb and forefinger, livelier if less controlled strokes will result. It may be worth your while experimenting along these lines to see whether they do anything for you; you may be pleasantly surprised or you may find you lose more than you gain. Whatever you decide, be assured that loosening your brushwork and giving it greater freedom will help you greatly on your way to developing your own strong and painterly style.

With bolder brushwork and the use of larger brushes, it is difficult to show much in the way of detail and that is all to the good. Fiddling detail that contributes nothing to the impact of a painting is best omitted, and the larger brush will exert a wholesome discipline. It is worth emphasising here that loose treatment does not mean a slapdash approach. Though the actual painting time will be less, the

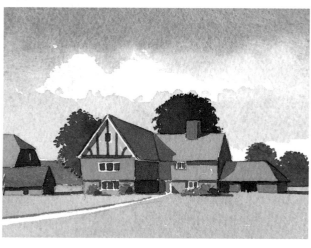

Here is an example of a meticulously painted farmhouse. Everything is exact and tidy and nothing has been left to the imagination. Not very impactive or convincing.

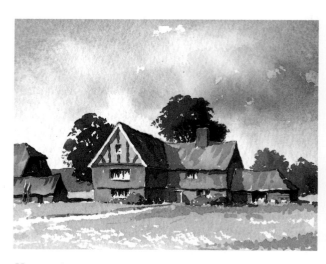

Here is a looser treatment, with the brush given freer rein and no attempt made to include every detail – but it surely presents a stronger image.

Here is a tree in which the attempt has been made to indicate every leaf – an approach doomed to failure.

The outline of the tree has here been loosely suggested by strong, uninhibited brushwork and the result is altogether bolder.

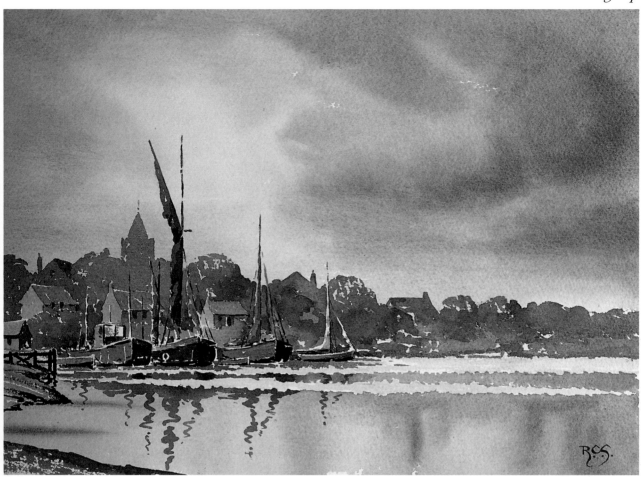

planning time should be greater, for you cannot afford to apply bold brush-strokes and washes without thinking very carefully beforehand just what effect you want and how exactly you intend to achieve it. Blundering on with no clear-cut plan will almost certainly end in disaster. If you are uncertain how a boldly planned brush-stroke will look, try it out on an offcut first. As watercolour lightens appreciably as it dries, what may look over-strong when first applied may prove just right on drying.

Some detail may best be suggested by a technique known as the broken wash, in which specks of white paper are left when a large, loaded brush is drawn rapidly over the surface of a rough watercolour paper. Such treatment may suggest an expanse of shingle, a field of rough grass, sunlight sparkling on water or any manner of surface for which a feeling of texture is required. The effect obtained is so much more direct and satisfactory than, for example, dozens of meticulously painted little stones or seed heads. There is no reason why a broken wash should not be laid over a dry, paler wash if, for example, you want your pebbles to be sand-coloured instead of white. It is worth remembering however, that once a wash has been laid, some of the sizing in the surface

OLD TIMERS AT MALDON

A scene such as this, with a great deal of detail, can easily become over-worked and fussy so I decided to keep the treatment fairly loose and go for atmosphere and overall impression. The sky was cloudy with areas of radiance and as most of the tonal weight of the composition was on the left, the heavier cloud shadows were established on the right, to provide balance. The far bank, with its church, houses and trees, was put in with one variegated wash and when this was dry, just a little detail was added. The group of boats was given greater tonal contrast, to bring them forward.

45

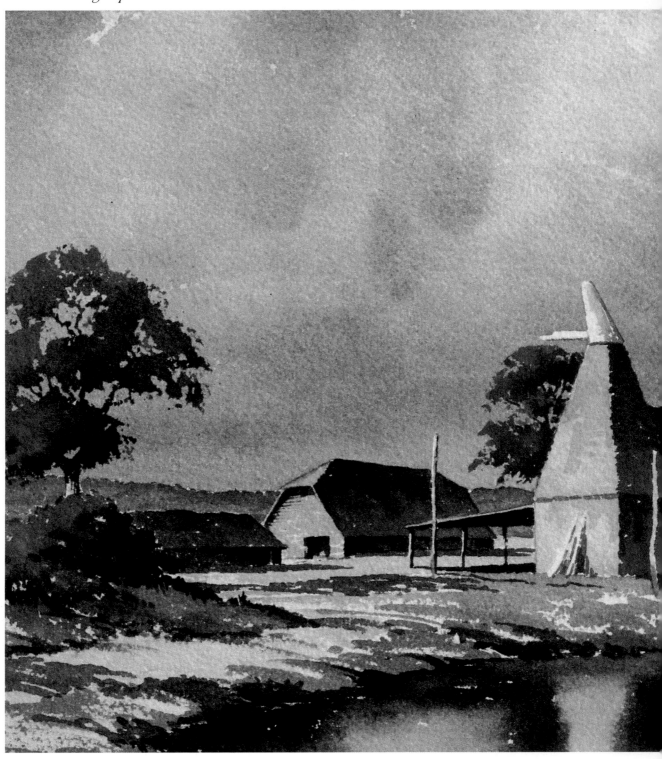

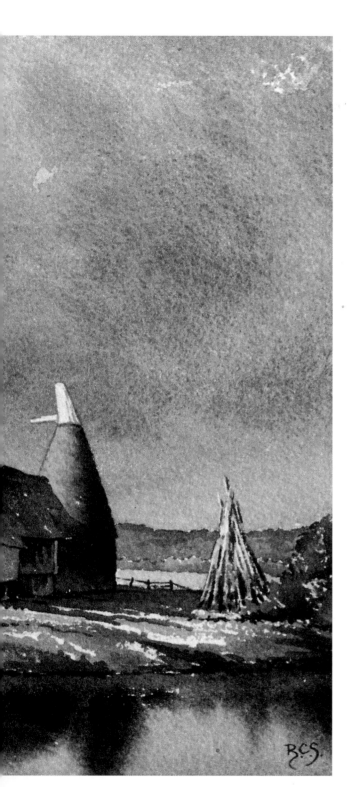

THE FARM POND

A freak early snowfall while the trees were still in late autumn leaf provided the subject matter for this study of Wealden farm buildings. The rapidly melting snow was simply the white of the paper left behind as loose horizontal strokes of a large brush described the rough foreground grass. It is a good plan to use deeper than usual tones for the sky when you are tackling snow scenes for this not only suggests snow-laden clouds but makes the snow appear very white by contrast. I emphasised the tonal difference between areas of light and shade and this contributed to the crisp image I wanted.

of the paper will have been disturbed and this will make it a little more difficult to obtain a crisp, broken wash. But with practice it can be done.

Another technique well worth adding to your repertoire is dry brush work. Here you use a brush lightly loaded with paint and draw it rapidly over the surface of the paper so that it only comes into contact with the little hills on the paper's surface. Although this is referred to as dry brush work, the brush

MEMORIES OF TYNESIDE

One of the problems posed by this subject was that of conveying the impression of a mass of industrial building on the far bank without getting involved in too much fiddling detail. I began by applying a wash of pale raw sienna over the whole paper, slightly warming it here and there with light red. While this was still wet I dropped in a mixture of ultramarine and light red for the mainly horizontal forms of the clouds. When everything was dry I painted the far bank in a single wash, using the same mixture as for the clouds, and leaving a few odd shapes to suggest roofs and other features. The foreground buildings and the moored barges were painted in much deeper tones to contrast with the distance and make it recede.

should not be *too* dry or the paint will look muddy and drab. Naturally this technique works best on rough paper though it can be used quite effectively with not.

There are certain textural effects that can be obtained with the help of extraneous aids. Opinions differ on their value and they tend to be despised by the purists. On the credit side the effects they can produce often look more spontaneous than those resulting from laboured brushwork. Here are a few that you may care to experiment with:

1. If you sprinkle sand onto a wash that is still wet, the pigment will gather round the grains. When the paper has dried and the sand is brushed off, the effect of pebbles may be created.
2. Salt, similarly sprinkled on a wet wash, will produce, on drying, an effect of granulation and texture.
3. Crumpled paper, pressed onto a drying wash, can represent the appearance of a rocky surface.
4. Turpentine, added sparingly to a freshly applied wash, will produce a marbled texture on drying.
5. A piece of candle wax lightly rubbed over the

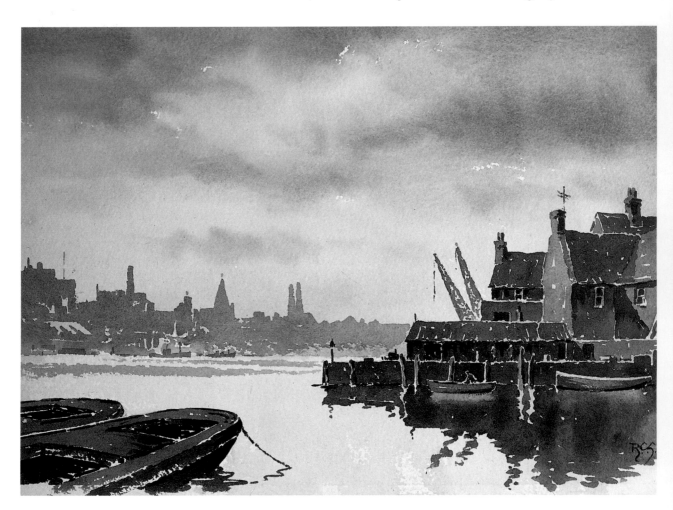

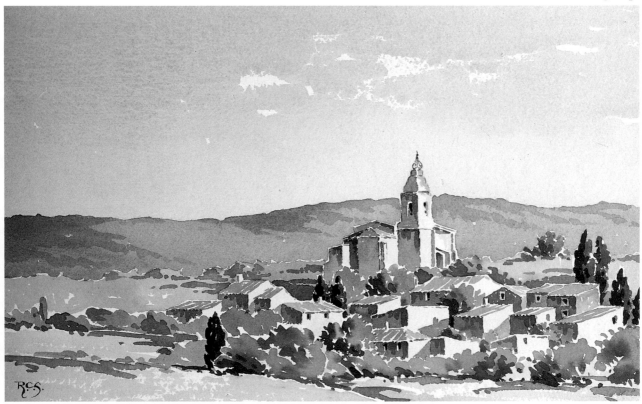

surface of a rough paper will act as a resist, to produce a broken, speckled effect.

6. More exact areas of white may be preserved by using masking fluid, a form of liquid latex. It is useful for such details as white windmill sails against a stormy sky, for it allows the background wash to be applied boldly.

7. Still larger areas may be preserved by applying masking tape. Some of the softer papers are unsuitable for use with masking fluid and masking tape and tend to lose surface fibres when these materials are removed, producing a ragged outline.

8. A sharp blade, such as a scalpel or craft knife, may be used on dry surfaces to produce white marks or scratches. These can stand for foreground stalks or grasses against a darker background, for highlights and so on.

These and similar aids should only be used with the utmost discretion or their effect can become tiresome.

Finally, remember that boldly painted watercolour passages always look fresher and more effective than areas that have been laboured over, and that as your spontaneity and skill develop, so will your style.

STE. MADELEINE, BÉDOIN

Provençal villages provide delightful subject matter for the artist. Their geometric patterns of white walls and terracotta roofs, punctuated by the dark verticals of cypress trees, are usually grouped around fine, old churches which provide useful focal points. The problem is to avoid allowing so much detail to result in over-elaboration and over-working. At Bédoin the lofty church tower conveniently links the planes of the sky, the distant hills and the village and so helps the composition.

The sky was a single variegated wash of ultramarine, modified by raw sienna at the horizon, and the quick lateral strokes of a 1 inch flat brush left little chips of white paper to suggest a few summery clouds. Below, the treatment was bold and direct.

ATMOSPHERE AND THE ART OF SUGGESTION

Before the invention of photography a high proportion of paintings were literal portrayals of their subject matter. Although the giants among the old masters brought understanding and inspiration to bear upon their work, they were none the less essentially representational in their approach. With the advent of photography the task of mere recording became ever less important and artists were freed to follow their own quest into the richness of the world about them, to look beneath the surface and express their own reactions and emotions. The Impressionists were obsessed with the effects of light and brilliant prismatic colour and, in exploring that avenue with flair and single-mindedness, sacrificed detail and often topographical accuracy in the process. This fundamental change in the concept of art and of its *raison d'être* has long been universally accepted and far more is rightly expected of artists than the painstaking production of pictorial records. For the artists themselves the change has had a liberating effect and the majority have taken full advantage of it. Indeed, in the field of abstract art, the tie with realism has been severed altogether. Here, however, we are concerned with representational painting and with exploring ways in which atmosphere, feeling and emotion may breathe life and meaning into our work.

Paintings are often more appealing if they rely to some extent on suggestion and leave something to the imagination of their viewers. A painting that describes in literal detail every facet of a scene rarely evokes the same response as one in which there is an element of intriguing mystery. When aspiring artists first take paints and paper into the countryside to

work in the open, they are concerned to reproduce as faithfully as they can what lies before them. As they grow in experience and confidence they come to realise that it is the atmosphere and feeling of a scene that should really concern them and so their approach and their style adapt to the new demands made upon them.

Of all the media, watercolour is the best suited to capturing the often fleeting effects of weather and atmosphere, particularly in countries prone to mist and cloud. The painting of skies is covered in some depth in a later chapter; for the moment we need only note that the best effects are obtained by using full, liquid washes, allowing the paint to flow and, with luck, to do some of our work for us. Full washes certainly need to be controlled but the less modification they receive after being applied, the fresher and clearer they will be. True, wet passages may be altered and developed without real danger as long as they remain wet and this often gives us time to make necessary corrections to certain passages in the landscape. But where real clarity is essential, for example in painting skies and sheets of smooth water, the less modification the washes receive, the fresher will be the result.

The subtlety and transparency of watercolour make it the ideal medium for capturing the effects of mist and for accentuating aerial perspective, a term which may need some explanation. Linear perspective constructions create the illusion of objects receding into the distance by virtue of converging lines and diminishing size. With aerial perspective the effect is reinforced through tone and colour. The earth's lower atmosphere contains dust, smoke and,

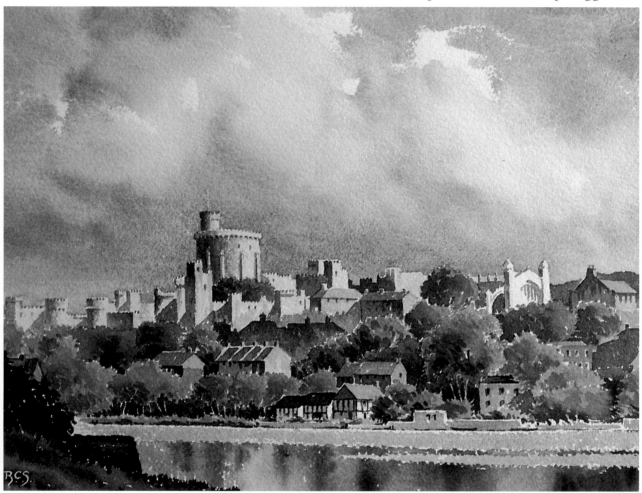

WINDSOR CASTLE

This view of Windsor from the banks of the Thames contains a great deal of detail and the problem was to indicate the mass of buildings and trees without getting bogged down in over-meticulous working. The answer to this problem is simplification, a process which with some subjects can be taken to extreme lengths, often with telling effect. Here it was a question of compromise. Much of the castle masonry in full light is simply the white of the paper, form being achieved by the addition of a grey wash to denote shadow patterns. Some of the rows of houses are just deep toned silhouettes, but the more precise treatment of a few individual buildings creates the illusion of more detail than there really is in the painting.

Two strips of pale, ruffled water separate the subject from its reflection in the river and this reflection has been kept soft to avoid competition with the busy scene above.

most of all, water vapour and so the appearance of distant objects is bound to be affected. Obviously, the mistier the conditions the more that effect will be. The influence of intervening atmosphere can manifest itself in three ways: first there will be a change in colour, a progressive cooling to soft blues and greys (the 'greying' effect of distance); second there will be a progressive decrease in tonal contrast so that an object, such as a house, which at close range has strong lights and darks, will appear on the horizon as a pale grey silhouette; the third effect will be a softening of the outlines of more distant features. In this instance the thickness of the mist is likely to obscure the far distance, and the near middle distance may be as far as we can see.

A line of distant hills may be indicated by a pale wash of blue/grey, perhaps ultramarine with a little light red. If there is any indication of light and shade, that may be shown by dropping in a little more colour here and there, though the tonal contrast must remain very limited. Where the mist has the effect of softening outlines, an entirely new technique is needed – the 'wet in wet' approach. This is how it works: if you wish to paint the misty outline of a tree

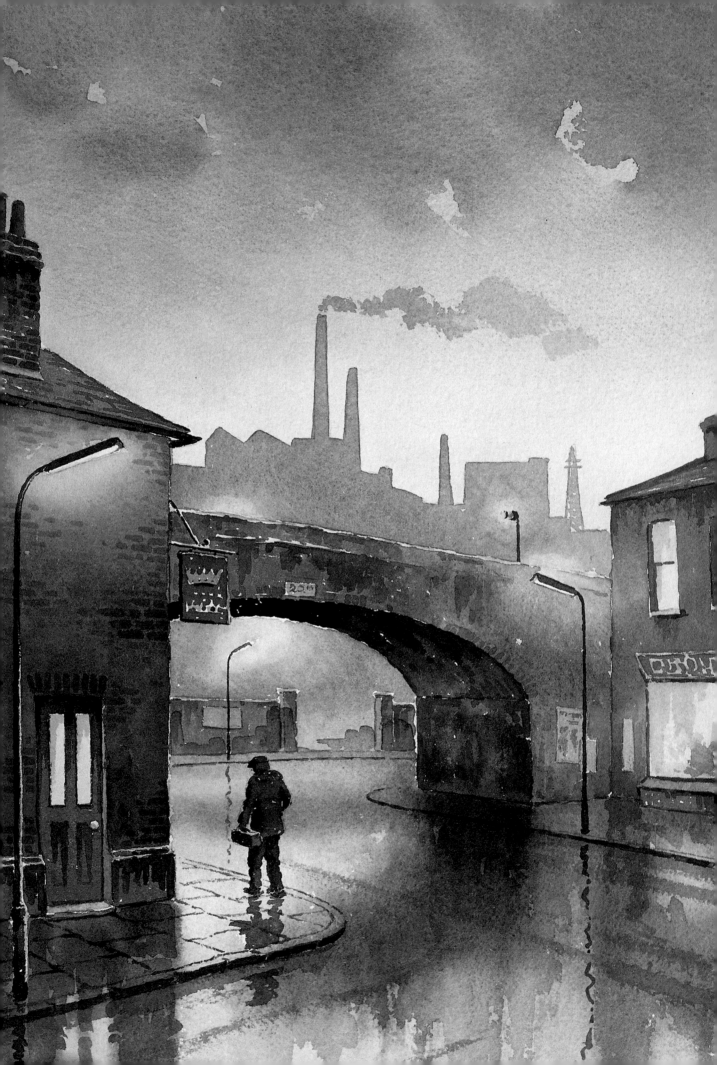

◁ LATE SHIFT

The object of this painting was to create the murky, drizzly atmosphere of a back street in an area of heavy industry. The smoke-laden air imparts a warmth to the early evening light. The very limited palette consisted of light red, raw sienna and ultramarine and the fact that these three colours alone appear in varying proportions in all parts of the painting ensures its unity. The warm grey silhouette of the distant factory buildings suggests mist in the atmosphere and was put in with one liquid wash. The wet road reflects the lights and darks above and zigzags into the centre of the painting. The solitary figure has been placed against a patch of reflected radiance and lights have been used against darks wherever possible.

SUN AND MIST, WHARFEDALE

The wet in wet technique is ideal for capturing the effects of mist. In this Yorkshire Dales scene a misty sun softly illuminated the distant moorland and cast equally soft shadows. In the foreground the effect was altogether crisper and this contrast created a strong feeling of recession. I established the sky first, using a weak wash of raw sienna and another of ultramarine and light red. I allowed these washes to blend and brought them down to the tops of the buildings and the other foreground features which required a crisp outline. While this background wash was still wet – but not too wet – I dropped in more of the second wash to suggest the soft outlines of the distant hill and the bank of trees behind the line of washing.

When all this was dry I painted in the buildings and the foreground, emphasising the strong tonal contrast between light and shade and preserving the lines of light where the sun caught the tops of roof and wall.

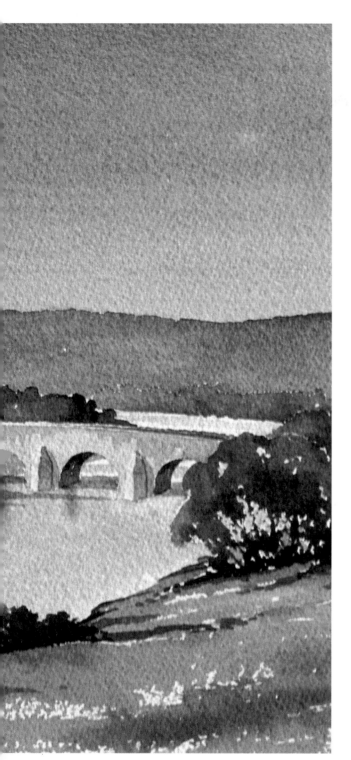

DORDOGNE BRIDGE

The feature of this view of the river that attracted me was the lovely shine on the smooth water and I resolved to do all I could to do it justice. There were some deep but soft-edged reflections from the far bank, but to the right the water mirrored the pale tones of the sky. In order to emphasise this reflected light, I deepened the tone of the foreground grass to provide contrast.

Notice how the group of bushes prevents the eye sliding off the painting to the right and how the church spire – a small but dominant feature – is placed firmly to the left of centre.

against a pale sky, for example, you lay in the sky wash in the normal way and, while the surface is still wet, you drop in the darker colour to represent the tree. Because you are painting into a wet surface, the washes will merge and the tree shape will be soft-edged. As one would expect, it is not nearly as simple as that and both practice and experience are necessary before one can be sure of obtaining the desired effect. The crucial factor is the degree of wetness of the first wash. If it is still too wet, the second wash will disperse into it altogether and be lost. If, on the other hand, it has become too dry some hard edges will occur and the result will be thoroughly unsatisfactory. Another word of warning here: if the second wash is more liquid than that already applied, a

CORNISH ESTUARY

The more complex the scene the more necessary it is to simplify, if the message is not to be buried under a mass of irrelevant detail. Here the soft evening light, the misty distance and the boats at anchor on calm water combine to create a feeling of peace and tranquillity which an excess of detail could easily have destroyed. Consequently the sky and water are a single pale variegated wash, from cool to warmer colour, and the far shore is a simple wash of soft grey with just a few shapes left untouched to suggest objects by the water's edge – exactly what, is left to the imagination of the viewer.

phenomenon known as 'flowering' will occur. Here the liquid in the second wash will carry its pigment as far as it can into the drying surface of the initial wash and deposit it in unsightly concentrations where it is least required. As with so much in art the only real solution to the problem is practice, so that you may judge with some confidence the moment to apply the second wash. This is usually when the shine just begins to go off the surface of the paper, but this is not an infallible rule, for different makes of watercolour paper vary in their behaviour.

It is possible to adjust both the softness of the outline and the depth of tone of the superimposed image. The damper the initial wash, the softer the outline; the less damp it is and the stronger the tone of the superimposed wash, the more definite will be the result. These variations are extremely useful in painting a group of receding objects, for although all will be soft-edged, their softness will increase progressively with distance. If you have not mastered the wet in wet technique, make up your mind to do so – it will stand you in good stead and give your work an extra dimension.

We all admire the skill of artists who possess the ability to suggest their subjects vividly and convincingly without painting every part of them in laborious detail. Sometimes their work looks as though it were painted at breakneck speed and yet it conveys a powerful and effective image. Such confident skill

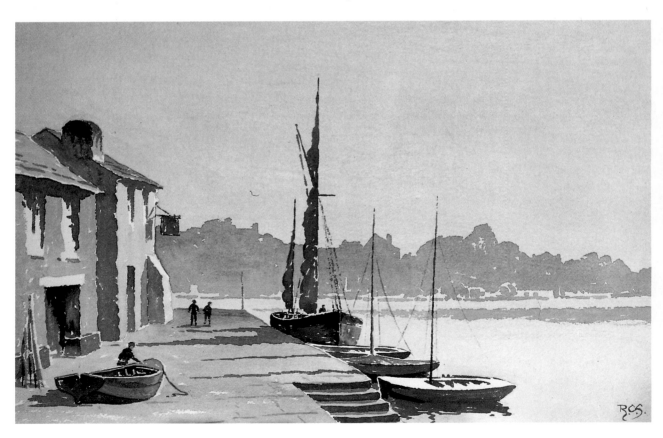

only comes with effort and industry. The impression of speed is at least partly illusory, for although the paint is obviously applied quickly and directly, much careful thought goes into each strongly painted passage before the artist goes into action. It is not least a matter of omitting inessential detail and with little experience it is not easy to decide what is necessary and what is not. If you study your subject in depth certain omissions may suggest themselves, and at times you may think of a way of representing some complicated feature in a simple and direct manner. With perseverance and self-criticism you will gradually evolve your own form of pictorial shorthand and the freedom of your work and your own personal style will develop with it.

THE SHELL SEEKER

This is a studio painting made from an old sketch of my son looking for shells along a strip of wet sand left by the receding tide. I decided to paint the figure in deep tones to make it stand out boldly against the pale background of sea. I imagined a low mist obscuring the horizon and, in fact, all but a few of the nearer waves, a device which helped to focus attention upon the small boy and his reflection in the wet sand. I used a little masking fluid to preserve the flecks of foam in the foreground water.

DEMONSTRATION 2

LERYN CREEK

This Cornish tidal inlet winds its way between low wooded hills up to the old market town of Lostwithiel. The jumble of buildings on the left and the whitewashed cottage on the right stand out against the darker knolls behind and the winding river leads the eye into the far distance. The water was the most important feature of the painting and you will notice how the tone of the sandy banks has been varied to provide counterchange – light where the water appears dark, deep where the river is re-flecting pale sky. The main weight of the composi-tion is on the left, but balance has been provided by the heavy grey cloud on the right.

Stage 1

Because there is plenty of detail in the lower half of the painting, the sky was simplified into one large billowing cloud. Very pale raw sienna was used for the sunlit areas, soft ultramarine and light red for the cloud shadows and pale ultramarine for the area of blue sky, all three washes being applied with three large brushes in one operation. The warmer wash for the lower part of the sky was carried down to the line of distant water.

Stage 2

A second wash of ultramarine and light red increased the tonal depth of the cloud shadow on the right and this helped to balance the composition. The lower part of this wash was left hard-edged to suggest the ragged underside of the cloud but the lighter top was softly blended with pure water into the original wash.

The distant hill was pale raw sienna and Payne's grey on the left, to indicate pale sunlight, and ul-tramarine with a little light red to suggest shadow on the right. The low wooded hills in the middle dis-

tance were put in next, with variegated washes containing raw sienna, Payne's grey, ultramarine and a little light red. Their fairly deep tones were intended to provide contrast with the much paler buildings in front.

I wanted to separate the distance from its reflection and achieved this by painting narrow strips of much lighter colour to suggest foreshortened bands of disturbed water.

Stage 3 (Overleaf)
I began by applying a second wash of ultramarine and light red to the middle-distance trees, to indicate areas of shadow and to provide some texture. I then turned my attention to the buildings, using pale tones to ensure that they would register effectively against the darker background and paying particular attention to the cast shadows, some of which showed warm reflected light.

The river came next and for this I prepared several washes corresponding to the colours of the various elements reflected – the pale sky, the distant hill, the dark banks of trees and a small section of building. These washes were applied in one operation, to ensure a soft-edged effect. When they were dry, I painted in the sandy banks, varying their tone as I went to provide strong contrast with the water. I then put in the area of weedy grass at bottom left, using a dry brush technique over a plain green wash to suggest its rough texture. I finally added a few darker accents to indicate doors, windows, masts, cast shadows and so on, and the painting was finished. It can be seen overleaf.

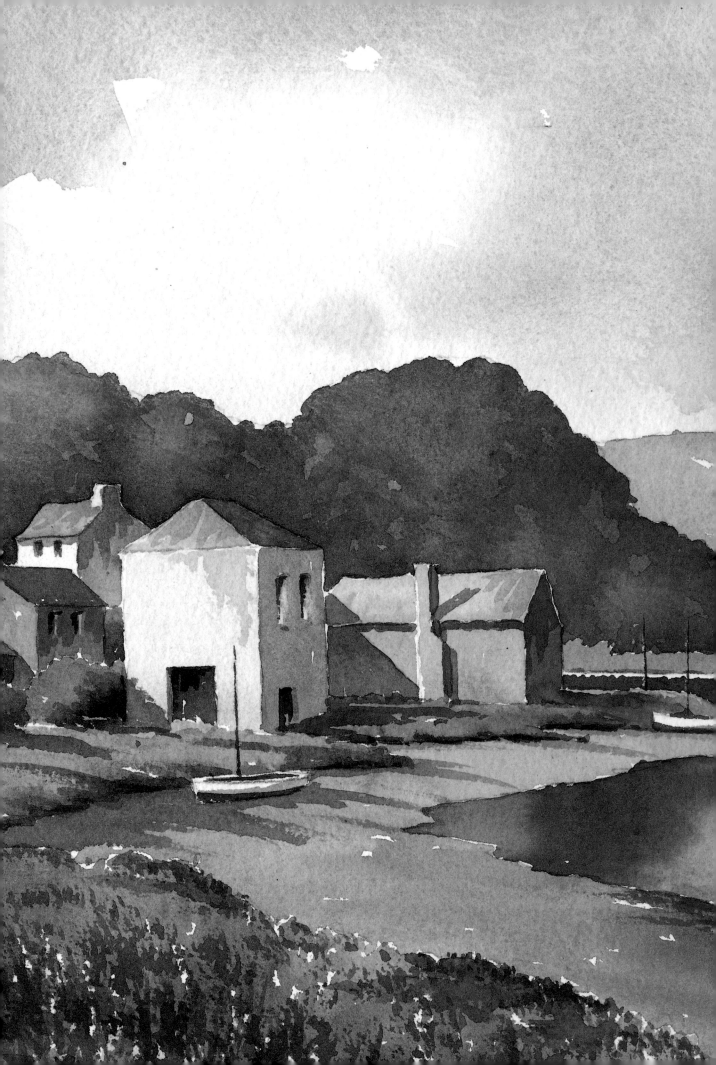

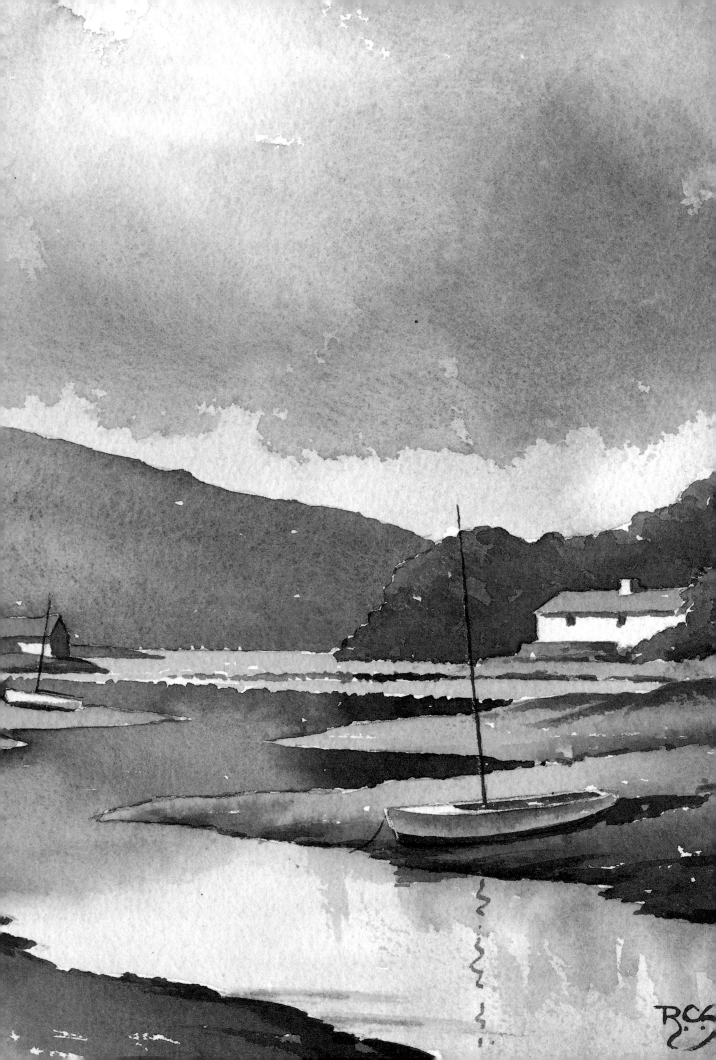

Chapter 6

PAINTING SKIES WITH CONFIDENCE

Watercolour is a versatile and expressive medium for dealing with all manner of subjects, but in my view is at its best when used with confidence and skill for capturing the effects of billowing clouds. The secret is to use plenty of water in your washes and to let those washes flow. Because so much water is used in this style of painting, it is vitally important to choose a heavy paper, of certainly not less than 200lb (425g), or, if you are using a lighter paper, to make sure it is properly stretched. Severe cockling of the support is bound to cause difficulty as the full washes collect in the troughs and premature drying begins on the ridges.

Ideas vary on the angle from the horizontal at which the drawing-board should be held, but obviously too steep an angle will result in the washes streaming down the paper. My usual angle is about 15° from the horizontal, a gradient which allows gravity to exert just the right amount of influence; and, as I tend to paint with the board on my knee, I am free to tilt it this way and that, to encourage the washes to flow where I want.

Some students find this bold, watery approach very difficult to control in the early stages and there is no doubt it takes a little getting used to, but once things begin to come together, as they will with perseverance, the results are so much better than those which flow (if that is the word) from a mass of timid little brush-strokes. Once you have made the decision to loosen up in your treatment of skies, get all the practice you can and make a point of painting, boldly and directly, any sky that takes your fancy. Skies make wonderful watercolour subjects and as you progress you will build up a collection of quick impressions. These are worth keeping both for possible future use and as a way of measuring how both your technique and style are steadily developing, which will give you encouragement and confidence. This improvement may not be a smooth upward curve, for in art we tend to progress by fits and starts, but improvement there will be if you stick at it.

In this country we are fortunate in the interest and diversity of our skies. Unrelieved blue may have some climatic advantages but the painter needs clouds of all types as well. We will begin, however, with the simplest type of sky – the cloudless variety. The first thing to do is to analyse its tone and colour. Overhead it may well be a strong cool blue but as our gaze moves down so the effects of the earth's atmosphere become more apparent and there is a gradual and progressive lightening and warming of its tone and colour. We should not allow ourselves to be too carried away by the intensity of the blue we see above us. If we try to match it literally, it is bound to look harsh and garish on paper. Watercolour is a delicate medium and although I am certainly not an advocate of the wishy-washy approach, a certain degree of restraint and understatement will produce a better result.

The most effective method is to prepare two generous washes, one for the blue of the upper sky and one for the warm colour just above the horizon. I use the word 'generous' advisedly, for if either wash runs out prematurely, there will not be time to prepare more and the work will be ruined. The blue could well be ultramarine with just a touch of light red to prevent it looking too hectic. The second wash might be of pale raw sienna, again with just a little

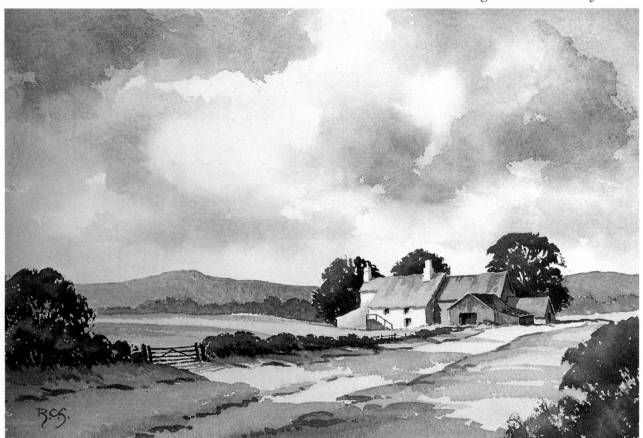

light red to warm it up. With a large brush, such as a 1in (2.5cm) flat, and plenty of the blue wash, paint a broad strip right across the top of your paper. If your board is at the correct angle, a bead of liquid paint will gather at the lower edge of this stroke and will then be taken up by your next brush-stroke. Continue in this way down the paper, and at about the halfway stage, start to dip the same brush in the warmer wash. There will of course still be some blue remaining in the brush, but this will gradually decrease and a gentle transition from cool to warm colour will occur as your horizontal brush-strokes move down the paper. Even at the horizon there will still be traces of blue in your brush but this is no bad thing. If all has gone according to plan, you will have produced a smooth variegated wash from top to bottom.

A word of warning here! Some of the softer and more absorbent papers are apt to retain the marks of the brush to produce an unacceptably stripy effect. The answer to this problem is to damp the whole of the sky area first, as evenly as you can, and that should do the trick. Because the damp surface will tend to dilute the paint, slightly stronger washes are necessary.

The trouble with skies of this sort is that they can look very smooth, bland and lacking in style. This is

SAWLEY MOOR FARM, WHARFEDALE

An impressive sky often merits the lion's share of the paper and the landscape may then be confined to a narrow strip below. The sky above this view of the Yorkshire Dales was undoubtedly lively but the farmhouse and its surroundings were also of interest and so the position of the horizon was something of a compromise – a little below the half-way mark. The heavy clouds, of the cumulus variety, were strongly lit from the left and the direction of the light was emphasised by the well-marked lateral shadows across field and track.

The sunlit areas of cloud were the white of the paper, warmed very slightly as they approached the horizon. The cloud shadows were a mixture of ultramarine and light red and I used both hard and soft edges to achieve the effect I wanted.

particularly so if the rest of the painting is treated in a freer and more impressionistic manner. An even speedier assault on the sky in the first place would probably result in little chips and specks of white paper being left untouched – these could stand for flecks of white cloud – and this rather rougher treatment should accord better with the rest of the painting.

Clouds are our next consideration, and although we will naturally derive most of our information

from our own observation, it is useful to know something about their type and form. There are four main classifications though these are not always clear cut and there is often a mixture of types to be seen. Cirrus are the high-level fleecy white clouds consisting of frozen water-vapour. Depending upon the wind conditions at high altitudes, they may present a complicated and repetitious pattern of small shapes and these are difficult to paint accurately without resorting to smaller brushes and an altogether slower approach – another instance calling

BILLOWING CLOUDS

Plenty of water was used in this quick study of a cumulo-nimbus cloud formation. The soft merging of the warm grey and soft yellow washes helped to give the clouds form and shape. Because most of the interest was in the lively sky, a very low horizon was adopted and the line of hedge and the foreground field were put in very simply in warm, rather misty colours which blended effectively with those of the sky. The sky has a dominant influence on the landscape below and it is vital to ensure that there is colour harmony between the two elements in order to preserve the unity of the whole.

for some drastic simplification. Stratus clouds, as the name implies, are level layers of water-vapour which may cover the whole sky or only part of it. At sunset they can sometimes frame an area of glowing sky to produce an effect beloved of Christmas card designers.

Cumulus clouds are the next category and many artists find these the most paintable of all. They are the rounded, billowy clouds, usually with level bases, which sometimes look solid enough to stand on. In sunlight they will shine brightly but they are dense enough to produce interesting shadows. The final category, nimbus, comprises the dark, ragged and threatening clouds which usually presage a storm. There are, of course, intermediate categories such as cumulo-nimbus and cirro-stratus but we need not go too deeply into these. What concerns us more is the technique necessary to do these magnificent phenomena justice.

To illustrate my method of painting cloudy skies, I will start with my favourite, the cumulus variety. It is unlikely that you will be able to get everything down before the formation you wish to paint has moved and perhaps altered shape, so you really need

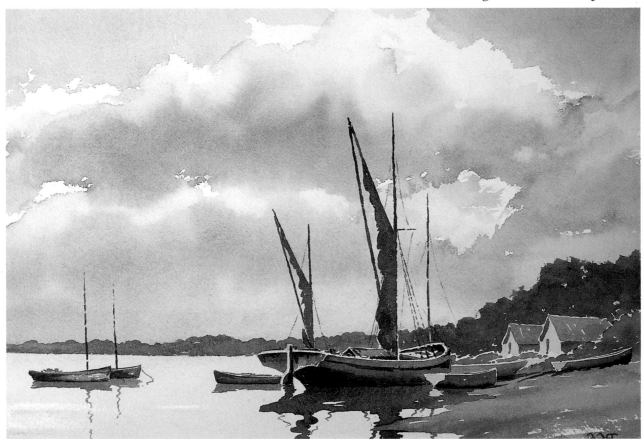

to freeze the initial image in your mind and then stick to that pattern. You should prepare three washes to represent (1) the sunlit areas of cloud, (2) the cloud shadows and (3) the blue sky. The first wash will be almost pure water, with perhaps just a hint of raw sienna or yellow ochre. The cloud shadow wash could be, for example, a mixture of ultramarine and light red, which produces a delightful grey with a hint of purple, or ultramarine with burnt sienna for a rather cooler effect, or a mixture of Payne's grey and alizarin crimson. Depending upon conditions, ultramarine or cobalt will serve for the blue of the sky, perhaps slightly tamed with a touch of light red.

I start by flooding in the areas of sunlit cloud with the first wash, leaving little chips of paper untouched to indicate highlights in the clouds. I then apply the grey wash to denote the shadows and of course this helps to give the clouds shape. Their shape is given further definition when the blue wash is added. A little manipulation with a brush dipped in clear water will improve the appearance of some of the clouds and soften a few edges here and there. But keep this to an absolute minimum or there will be loss of freshness. There are one or two points worth noting at this juncture: I do not wet the paper all over before going to work, as some painters do, because I like to have a mixture of hard and soft edges to give

SAILING BARGE AT ANCHOR

This is another subject in which the most striking feature is the shine on the smooth water and it was vital to preserve this by every means available. Consequently I used a very pale variegated wash which allowed the paper to shine through and deepened the tones of adjacent objects – the boats and their reflections, the foreground beach and the line of trees. The strong verticals of the barge's furled sails perform the useful function of linking the sea and shore to the lively sky. This is a painting which relies on strong tonal contrast.

(Overleaf) STORM CLOUDS, MEDWAY VALLEY

This quick watercolour sketch was made at breakneck speed in an attempt to capture the rapidly moving storm clouds. It is the sort of quick study you should tackle as often as you see a paintable cloud formation. The shadows of the cumulo-nimbus clouds were ultramarine with a little light red, the amount of the red being increased just above the horizon to create the merest suggestion of warmth. The highlights in the clouds were the white of the paper and the blue sky was a mixture of ultramarine and Payne's grey – all with plenty of water. With this bold and direct technique it is a mistake to attempt any tidying up for it is all too easy to lose freshness in the process.

the sky punch and style. Remember to vary the temperature of your greys as you paint, warmer near the horizon and cooler the higher you go. The same applies to the blue wash, which could be warmed with a little raw sienna for those patches lower in the sky.

The great thing is to work quickly and boldly and to stick to your original plan. Changes of mind and attempted alterations can only result in loss of that vital quality, freshness. Do not be dismayed if your first efforts are less than satisfactory. Your work will improve with practice and your style will develop with your increased confidence.

Skies are such a vital part of landscape painting that it is worth making a particular effort to achieve mastery. Remember to allow for the fading that takes place as watercolour paint dries, for what may look strong and impactive while everything is wet, may easily appear pallid and feeble when drying is complete. Even when you feel you have gone over the top with the strength of your washes, you will in all probability find that a strongly painted landscape below will quickly restore the balance.

Another matter you will have to consider is the position of the horizon. If the sky is a particularly dramatic one you may well wish to make a feature of it and so adopt a very low horizon. If, on the other hand, you are more interested in the landscape below, then obviously a much higher horizon is indicated, but remember that a small area of sky should be simpler in style and more restrained. If you wish

MEDWAY BRIDGE
This fine old ragstone bridge, with the group of oasthouses and other buildings behind, makes an attractive subject and a pleasing composition. I made several quick sketches and then enlarged the most promising, taking particular care with the perspective of the bridge.

The warm evening sky presented something of a challenge. The only cloud of any size – a subtle pinkish-grey – was soft edged below but the billowing crest was more definite. I applied a full variegated wash of raw sienna warmed with light red above the horizon and as this began to dry from the top, assisted by the slope of my board, I quickly painted in the cloud shape with a warm mix of light red and ultramarine. Timing is all important in a situation like this and I was in luck. The top of the cloud remained fairly definite, without being too hard, but the underside was soft edged. Careful consideration was necessary, too, in judging the degree of liquidity of the second wash. Too much water and flowering would have occurred; too little and all softness would have been lost.

to give your work cohesion and style you must, above all, ensure that the landscape is in harmony with the treatment of the sky. We have all seen paintings in which warm evening skies apparently have no impact at all upon the areas of cool green below. It sometimes helps to carry the warm wash of such a sky right down to the bottom of your paper. Chips of this wash, left unpainted, may then become puddles in a rutted track or perhaps highlights on some foreground features.

I hope my advice will encourage you to cast off your inhibitions and attack your skies with confidence and style.

SNOW OVER THE WEALD

In snowy conditions skies usually require deeper tones than usual, in order to make the snow appear much lighter by contrast. This heavier treatment also suggests there is more snow to come from the heavy cloud cover. In this impression of a Kentish farm under snow, the warm grey of the lower sky is a mixture of ultramarine and light red while much of the snow was simply the white of the untouched paper. Shadows in the snow are normally influenced by the dominant sky colour, as here.

LIGHT AND THE LANDSCAPE

Sensitivity to the quality of light is essential if you wish to paint it with conviction and feeling and you should train yourself to observe the subtle variations that exist at different times and in different places. The clear light of the Scottish Highlands has an ethereal quality in fair weather while the magical light of Venice, reflected perhaps from its network of canals, has a radiance that inspired Turner to produce some of his finest and most atmospheric watercolours. Turner devoted his life to the study and interpretation of light and some of the French Impressionists were equally dedicated to capturing its brilliant yet fleeting effects. There are no better ways of learning about light than constantly observing it yourself and studying the work of the masters.

Light has a direct and powerful influence on all we see and its special quality affects the tone, the colour and the mood of everything on which it falls. The countryside is only visible by virtue of the fact that light is falling upon it and so the quality of that light must exert a decisive effect on every part of it. Artists who have made a deep study of light in all its moods and succeed in capturing its elusive effects can produce work of breathtaking beauty and feeling. If you, too, cultivate an awareness and an appreciation of the quality of the light and its influence on the landscape, it will enable you to view the most mundane scenes with a fresh eye and will help you to paint with insight and style.

Having considered skies in some detail in Chapter 6, we must now examine the manner in which they influence the countryside below. The source of light is, of course, the sun, and on overcast days the cloud cover is illuminated from above and floods the land

with its diffused radiance. The heavier the cloud, the weaker the light, and when the sky is covered with dark nimbus cloud the effect is almost nocturnal. There is thus a wide range of light conditions with which the painter has to contend and he can only do this successfully if he studies the complete scene, both the sky and the land below, in conjunction and understands their interaction in tone and colour. At the risk of repetition, I emphasise again the overriding importance of really looking at the subject and studying it long and hard, for in art there is no effective alternative to thorough observation.

Part of the fascination of natural light lies in the diversity of its colour temperature. There is the cool light of morning, the rather warmer afternoon variety, the rosy glow of sunset and all the variations in between, and we must ensure that these are reflected in our treatment of every part of the landscape on which they shine. As watercolourists, we are well served by our medium, for its delightful freshness and transparency are ideal for enabling us to catch the subtle effects of light. Used well and imaginatively it will help to convey something of the mystery and magic of light and this will breathe life into our work. It is the sensitive interpretation of light that largely determines success or otherwise in conveying the atmosphere of the scene before us.

The quality of natural light is constantly changing and on days of broken cloud these changes can be disconcertingly rapid. We therefore have to work quickly before conditions change, to capture the fleeting impression we want. Speed of working will only come with practice and experience but when it does it will bring the added bonus of freshness and

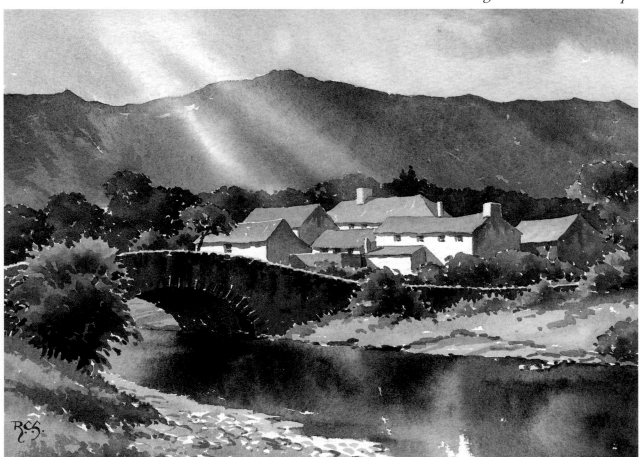

spontaneity to your work. The slow and laboured use of watercolour is rarely successful in capturing these desirable qualities. On clear days the sun will cast shadows and if you are working too slowly, these will shift noticeably long before you are ready; if you are not on your guard against this danger, the painting may end up with no consistent shadow direction. One answer to the problem is to establish the shadows early on and then you will be largely independent of what the sun does in the meantime.

As watercolourists we have nothing lighter in tone than the white of the untouched paper, and our problem is to make it appear to shine in order to reproduce the effect of light. As was noted earlier, the only way to achieve that is to employ very pale transparent washes which will allow the paper to shine through and then set beside them passages of much deeper tone. The strong tonal contrast will then create the illusion of shining light. The watercolour practice of working from light to dark will help here. Even when painting skies with a single variegated wash, it makes sense to start with the lighter, more luminous passages and work outward, to the more shadowed surrounding areas. If we do this, the lighter passages will be completed before there is any danger of the brush becoming sullied

GRANGE IN BORROWDALE

A gap in the clouds allowed shafts of sunlight to fall on the cluster of whitewashed cottages – their sunlit walls are just the white of the paper. While the purple-grey wash of the mountains was still wet, some of the pigment was removed with a damp brush to indicate the shafts of light. Notice how the pale roofs of the cottages stand out against the deeper tones of the trees and how the bleached pebbles in the foreground contrast with the dark reflections in the water. A pale broken line shows where the sun just catches the top of the bridge parapet.

with deeper-toned pigment.

Planning, always an important weapon in the armoury of the watercolourist, is particularly essential in the successful interpretation and rendering of light, for we cannot risk making mistakes and alterations if we are to preserve the illusion of shining light. Although some of the more expensive papers take alteration surprisingly well, there is always some loss of freshness and for this reason skies should never be altered.

If there is any water in the landscape, it may well reflect light from the sky and the same wash may be used for both. Light catching wet roofs, the puddled ruts of farm tracks and even wet roads should all be

established early in the painting, and care should be taken to ensure these important areas are not dulled by the encroachment of later washes. Areas of sunlit landscape will also receive early treatment and will provide telling contrast with the deeper-toned passages that will be added as the work develops. Cloud shadows over hills need careful handling if they are to be in harmony with the form of the land on which they fall.

If the scene before us has a marked overall hue – perhaps the golden light of a later summer afternoon – a wash of the appropriate colour may be applied over the whole paper to establish it right at the beginning. Various parts of this wash will need no

further painting, and these will give the painting a feeling of unity. While this wash is still wet further colour may be dropped into it to represent other features of the landscape and these will be attractively soft-edged, to suggest recession. If necessary, other parts of the initial wash may be mopped up with sponge or brush to create still lighter passages to represent areas of radiance in the sky.

When the overall initial wash has dried, nearer elements of the scene will be painted over it and these, being hard-edged, will provide contrast with the soft edges already established. This, too, will reinforce the feeling of recession.

Just as we should train ourselves to observe vibrant colours in surfaces in full sunlight, so we should learn to look for the rich and often subtle colours in cast shadows. Shadows painted a flat grey have little appeal and even if the overall impression appears to be one of grey, keen observation will usually reveal that it is made up of a variety of other, brighter colours. On a clear day, shadows contain a great deal of blue, reflected from the sky above, but warmer colours may also be present, reflected from adjacent objects in full sunlight; if you can indicate both in a single wash, you will succeed in giving your work

SPRING WELL FARM BELOW OLD PIKE

Much care is necessary when painting cloud shadows falling on undulating country, for it is all too easy to end up with areas of tone that fail to follow the form of the contours on which they fall. Here the grey shadows above the low barn are in harmony with the curve of the hillside. Notice how the lowering mass of the Old Pike stands out boldly against a patch of shining sky and is balanced by the heavy cloud to the left of centre.

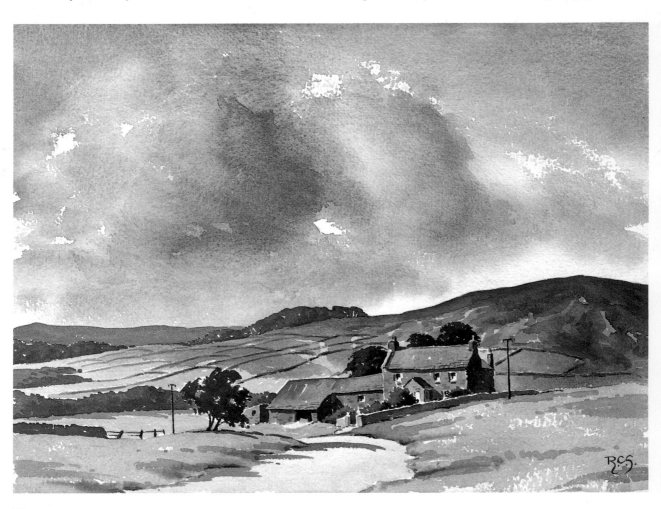

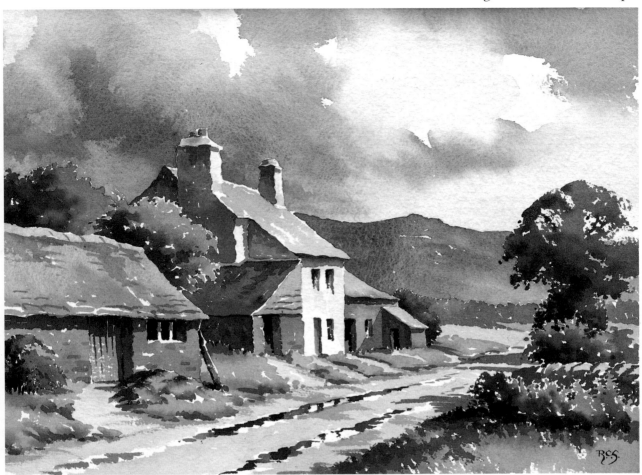

life, character and style. While on the subject of shadows, it is well worth bearing in mind that they are always deeper in tone as they approach the objects which cast them.

You can increase the impact of your rendering of light and shade if you employ what are known as lost and found edges. In artistic parlance, a 'lost' edge is one that merges into the background, either softly or by virtue of closeness of tone; a 'found' edge is clear-cut, with a hard edge and tonal contrast. Beginners are inclined to make all their edges sharp and clear, and this can give their work an air of artificiality and make their images look too much like flat stage scenery. If you allow one edge, perhaps on the shadowed side of a tree, to blend into the background, you will achieve a more realistic and painterly effect. It is also good practice to decrease the amount of definition towards the outer edges of your paper as this tends to concentrate interest in the centre, where the scene would naturally be sharper in the eye of the beholder.

Practice in capturing the often subtle or dramatic effects of light will benefit your work enormously and will greatly increase the finished painting's interest and impact.

DUNSTONE IN THE MOOR

This little group of farm buildings registers effectively against the brooding mass of Dartmoor and the heavy grey clouds above and this strong tonal contrast creates the illusion of bright sunshine. The low mossy roof on the left also stands out boldly against the deep tones of the trees and the shadowed side of the farmhouse. The way in which the light just catches the tops of the weeds and the low stone wall on the right of the painting reinforces the impression of a strong lateral light.

The buildings are balanced by the dark tree on the right while the reflections in the puddled ruts add interest to the foreground.

(Overleaf) HILL VILLAGE, PROVENCE

Light always plays an important part in landscape painting, however muted it may appear. When subjects are bathed in strong sunlight, its role is even more vital. In this quick, on-the-spot study of an old Provençal village, I sought to convey the impression of bright sunlight by emphasising the tonal difference between areas of light and shade. Sunlit masonry casting deep shadows strongly suggests brilliant light, particularly if those shadows contain a hint of warm, reflected light.

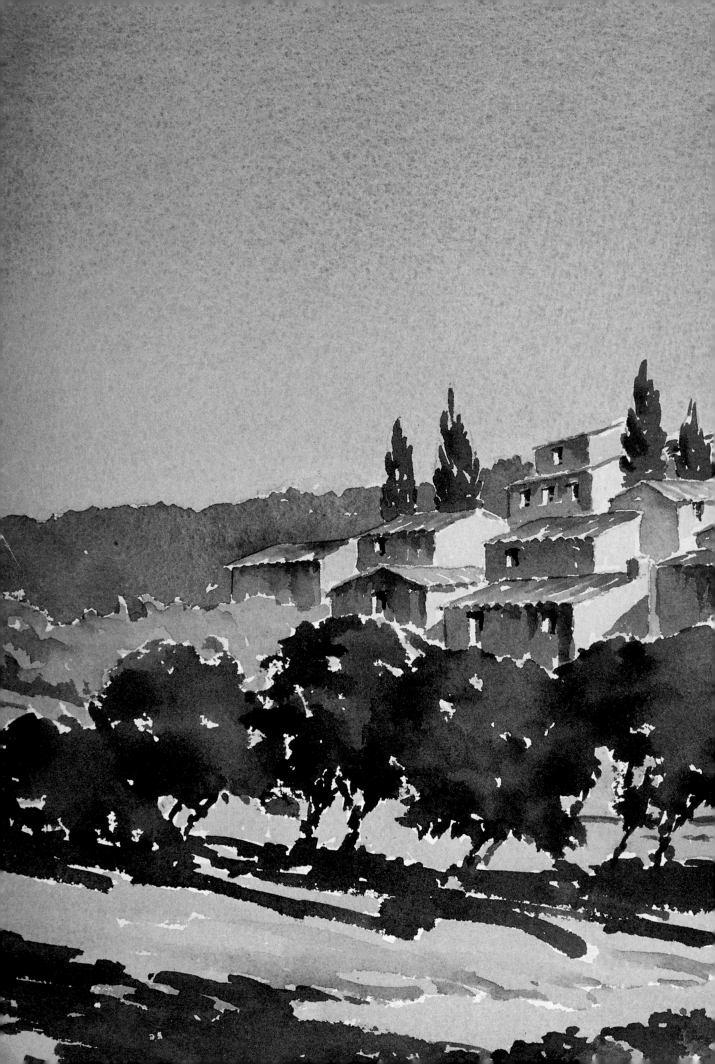

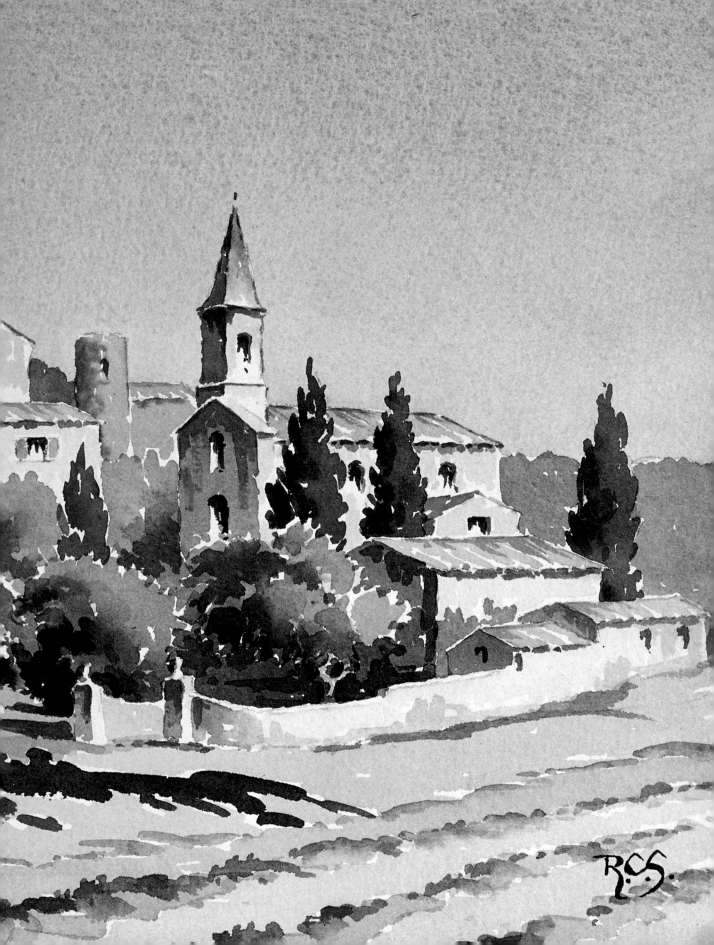

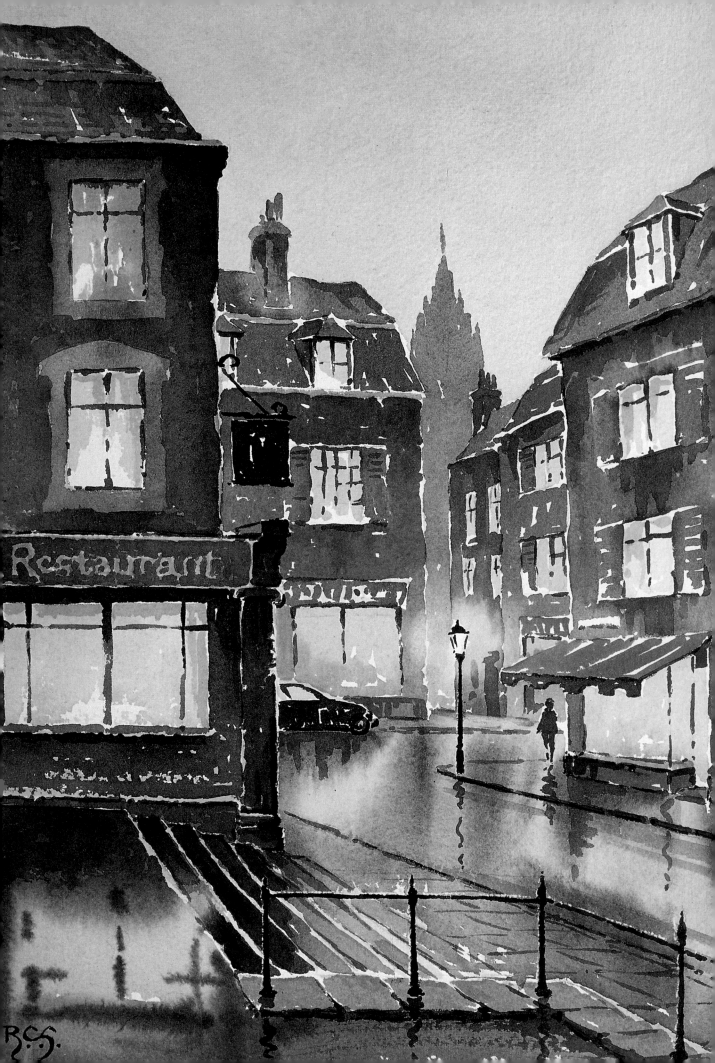

◁ AU COIN DE LA RUE

There is plenty of light in this urban scene and although an evening glow still lingers in the sky, most of the illumination is of the artificial variety. The paper has been allowed to shine through the very pale washes of warm colour used for the windows and shop fronts and this effect has been strengthened by placing much deeper tones beside them. The illusion of light has been further strengthened by the indication of its reflection in the wet street below. The road zigzags into the brightly lit centre of the painting where the lamp-post and the solitary figure provide dark accents.

LANE AT LECHLADE

Groups of buildings are usually best painted when there is a strong lateral light, for the mixture of lights and darks that this produces helps to give them a three dimensional look and also creates plenty of tonal contrast. In this painting the placing of dark trees against the pale, sunlit roofs has further emphasised the tonal difference between areas of light and shade, creating a crisp image.

Only in the foreground walls is there any real attempt to indicate individual stones, though a few random blocks suggest the building materials of the more distant houses.

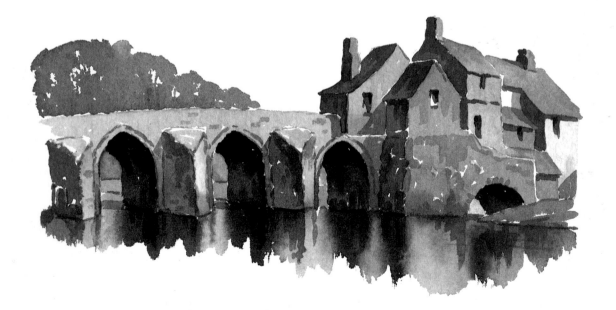

DEMONSTRATION 3

THE FLYING SCOT

This splendid old locomotive, steaming slowly and majestically through Didcot Station, provided the subject for a painting full of feeling and nostalgia. The low viewpoint gives the subject greater impact and its placement against a patch of luminous sky adds to the drama of the scene. There is no doubt about the centre of interest here – the rails, the platform edge, the station roof and even the figures of the railway buffs all direct our eye to the Flying Scot. The escaping steam helps to create atmosphere and conveniently obscures a superabundance of wheels.

Stage 1

I used just three colours for this painting – raw sienna, light red and ultramarine – and began by applying a variegated wash over the whole paper. The misty cloud was ultramarine and light red, the patch of radiance raw sienna and light red and the area of the rails dilute raw sienna. I could well have used masking fluid for these rails and that would have enabled me to carry the warm, greyish wash right down to the bottom of the paper. While the sky was still wet I dropped in some deeper grey for the smoke, gradually decreasing its area but increasing its strength towards the left of the painting. As I worked, so the initial wash started to dry and the 'smoke' spread rather less, just as I wanted.

Stage 2

The grey silhouette of the buildings on the left was a liquid wash of ultramarine and light red and this was carried right across the lower third of the paper and blended into the original wash on the right with pure

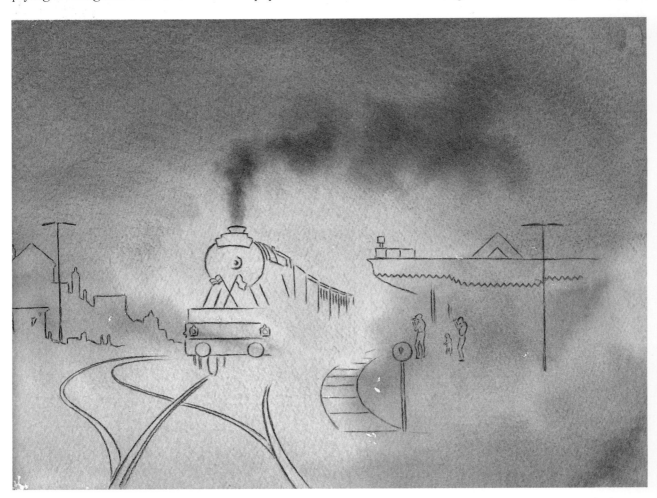

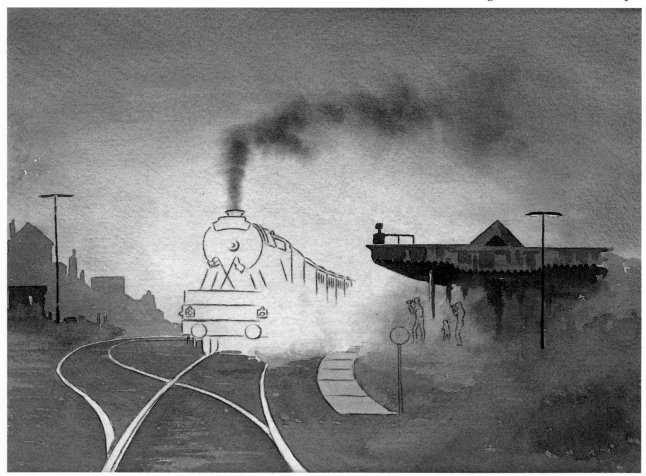

water – leaving, of course, the rails and the platform edge untouched. When this was dry a texturing wash of the same colour was added to the foreground and carried up into the nearer buildings.

Finally a much stronger mix of the same two colours served for the light standards and the detailing on the buildings.

Stage 3 (Overleaf)
A few horizontal strokes of the same mixture of colours suggested the presence of sleepers on the permanent way and then the figures and a few foreground details were put in. The locomotive itself I kept till last. To make it stand out dramatically against the glowing sky I used deep tones but took good care to preserve the various highlights on its front and side. These deep colours were blended with pure water into the area of escaping steam to produce a soft-edged effect.

This treatment of the Flying Scot is not perhaps as detailed as some railway enthusiasts would like but it conveys something of the atmosphere of the scene.

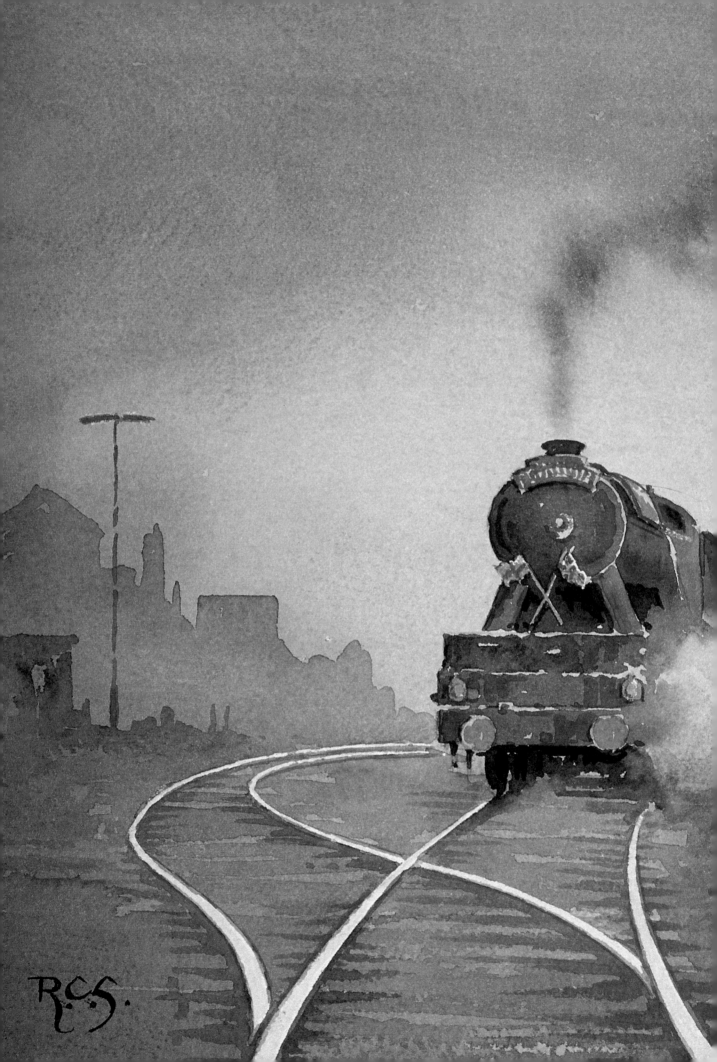

Chapter 8

FEATURES OF THE LANDSCAPE

We have now come to the treatment of those elements that together make up the typical landscape – trees, fields, buildings and water – and I hope to show you ways in which they may be painted with freshness, vigour and style. Although for the sake of convenience we are here dealing with them one by one, it must be remembered that, as part of the same landscape, their treatment must be consistent and cohesive, with no loss of unity. Do not try to put too much into your painting; select that which will add to its effectiveness and avoid overcrowding. There is often some feature of the scene before you which captured your imagination and in fact persuaded you to paint in the first place. If you concentrate on that particular feature, whatever it may be, and really study it in depth, you will be able to express your feelings about it more convincingly.

Inexperienced painters find trees an endless source of difficulty. They have been told to study and analyse their subjects carefully before attempting to put brush to paper, but the more they look, the more intricate detail they see and the more confused they become. If you wish to develop a bold style, you have to make up your mind to simplify and see your subject matter in terms watercolour can cope with. This applies with particular force to trees and foliage generally – always look at trees as masses and disregard detail. If you view them through half-closed eyes, this will help you to see them as a whole and to observe the grouping of the light and dark areas.

If you make a point of studying the bare outlines of winter trees, this will enable you to paint them more convincingly when they are in full leaf, for you will be aware of their underlying structure. Bare trees, with their intricate tracery of twigs and branches, also present the watercolourist with the problem of just how much detail to include. The trunks and main branches must be established boldly but the smaller branches are often best dealt with by using a dry brush technique while the fuzz of twiggery at the ends of the branches can be effectively rendered by a wash of a tone to represent the twigs and the sky beyond. Inexperienced artists usually have difficulty with forward-pointing branches and are sometimes tempted to omit them altogether, producing trees that look as though they have been sliced down the middle!

The complicated outlines of trees in full leaf constitute a similar problem and the attempt to paint every spur and indentation of their broken outline is bound to result in tired, over-worked images. We know that in watercolour the fresher and more direct the method, the bolder and more effective the result, so let us apply this philosophy to painting trees. First prepare a wash for the lighter areas of the subject, and another, stronger wash for its darks. If you apply the first wash with a series of quick strokes made with the side of your brush, this will result in a broken outline which may well approximate to the shape of the tree and the result will look spontaneous instead of laboured. Before the first wash dries, drop in some of the darker wash to correspond to the dark areas you have observed in your model. The rougher the surface of your paper, the more effective this method will be and the more fragmented the outline. It will also enable you to leave random 'sky holes' here and there and these will further increase

the impression of realism. Do not be tempted to use too dry a wash as this will tend to look dull and muddy on drying. Fuller washes are admittedly more difficult to control for this sort of work but with practice you will be able to handle them.

Colour needs equally careful consideration in order to avoid the all too common mistake of painting the foliage a strong and unrelieved green. Green is, of course, the main colour in summer foliage but it varies considerably between trees of different species and often contains other warmer colours as well. Your work will be far more interesting if you include and even exaggerate these other colours, paying special attention to the cooler, darker hues of the shadowed areas. These naturally occur on the sides of trees away from the source of light and on the undersides of branches. In establishing correct tone values, you will greatly enhance the realism and the three-dimensional appearance of your trees.

Landscapes can sometimes be enhanced by the inclusion of a frame of foreground branches which can add a feeling of depth to a painting. It is, however, a device fraught with difficulty for the unwary. If the twigs and leaves are too close to be treated as masses of tone and colour, as they probably will be, they

WOODLAND POOL
One of the difficulties of painting woodland stems from the mass of detail it contains – the maze of leaves, twigs, branches and trunks and the complicating effects of light and shade. In watercolour, any attempt to reproduce all this detail faithfully is bound to lead to over-complication and over-working and the only way to produce work of freshness and style is to simplify and concentrate on capturing atmosphere.

In this painting the backdrop of woodland has been drastically simplified and is represented by a single variegated wash. The two features of the scene that first appealed to me were the patch of bright sunlight against the shaded area beyond and the strong pattern of the bare trees against the mass of softer foliage behind. Both have been emphasised.

(Overleaf) AUTUMN, ROSS-ON-WYE
This painting exemplifies several of the points discussed in the text. The lively sky suggested a rather low horizon. The mass of buildings was dealt with in some, but not too much, detail while the church spire, placed right of centre, was painted strongly to register against a patch of luminous sky and provide a well-marked focal point. The middle-distance trees were much simplified and mostly painted in a single wash of varying colour and tone. Two strips of pale, disturbed water separate the middle distance from its reflecion in the river and dragged brushwork suggested the rough grass.

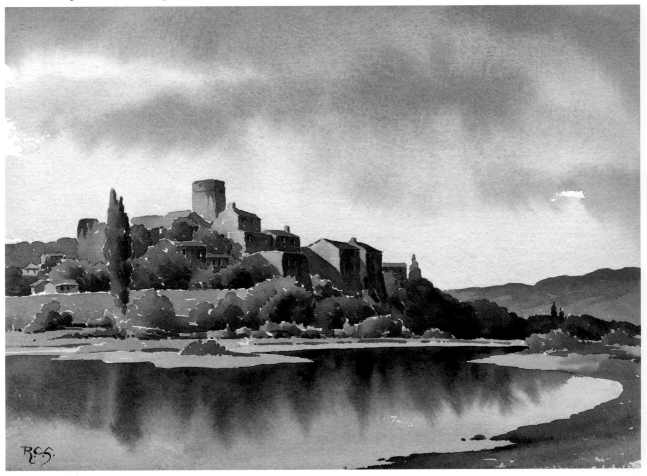

MONCLUS

Another Provençal hill village with the old stone houses clustering round the four-square shape of the church tower. The main mass of the village is to the left of centre and is balanced by the deeper tones of the shadowed area to the right and the line of blue-grey hills in the distance. There is plenty of tonal contrast in the buildings and this helps to establish their form and that of the village. There is equally strong tonal contrast at the margins of the river – the pale sand against the deep reflections by the far bank and the reverse in the foreground. It always pays dividends to give careful thought to tone values in planning your painting: correctly observed they can add enormously to the strength and impact of your work.

have to be painted individually and it is all too easy to become ensnared in a mass of detail which may accord ill with the rest of the painting. If you are tempted to add a fringe of nearby foliage, try out your treatment on scrap paper first – it may persuade you to leave well enough alone!

Pay particular attention to the ground shadows cast by trees. It is a common fault to paint them as though they were falling across a dead level surface; correctly observed, they will help to describe the un-

even surface of the ground over which they fall. Make sure, too, that you employ the techniques of aerial perspective, already described, to indicate the recession of more distant trees.

Let us now turn our attention to painting fields. Middle-distance fields are no great problem and can usually be indicated by simple washes of the appropriate colour, several tones lighter than adjacent trees and hedges. Problems begin when they are close enough to constitute foregrounds and this is where it is all too easy to be tempted into including an excessive amount of detail. This will not only tend to look over-worked but will lure the eye away from the centre of interest, which may well be in the middle distance. Once you start painting individual leaves and grasses, the compulsion to fill the space around them with similar detail is hard to resist. It is usually better to treat foreground fields more broadly and impressionistically so that they do not demand undue attention or compete with the more important subject matter above.

Bold, horizontal strokes of a large brush loaded with a wash of the appropriate colour and tone can suggest quickly and simply the texture of the foreground, particularly if used on a rough paper. Areas

of shadow and surface unevenness can then be added where necessary with quick horizontal strokes of a smaller brush and their uneven edges will reinforce the impression of a rough surface. You may think the result looks rather unfinished and be tempted to tidy it up and add more detail but the chances are that it will look fresh and quite convincing as it is.

Ploughland can provide an effective foil for fields of grass and cereal, especially if the soil is of an interesting colour, but there are pitfalls here as well. It is all too easy for the parallel furrows to be painted in such a way that their perspective does not accord with that of the surrounding area and does not reflect the undulations in the surface of the ploughland. Never attempt to paint every furrow in the field but concentrate on a few of the nearer ones and merely suggest the others. It is a good plan to exaggerate the unevenness of their form, however expertly the field has been ploughed, or they may look too regular and mechanical.

Farm buildings can add much interest to landscape paintings and often provide attractive centres of interest. The older variety, built of stone, brick, tile or timber, make particularly appealing subjects and their weathered materials blend pleasantly with their rural setting. The newer concrete and asbestos types have less to commend them, at least from the artistic viewpoint, and I am usually tempted to omit them altogether, sometimes to the indignation of the farmer who has given me permission to paint on his land! It is a mistake, however, to concentrate too much on the picturesque, and a certain amount of clutter and dilapidation will add character to your work. So resist the temptation to tidy everything up and remember that even such unpromising material as rusty corrugated iron can be a rich source of colour and texture.

The often wayward lines of old buildings are a gift to the artist and should never be straightened out. On the contrary, they may well be exaggerated, to add character and interest. Even modern buildings look

THE THAMES AT LECHLADE
I was attracted by the subtle colours of this peaceful scene and by their soft reflections in the gently flowing river. Its surface was smooth, but not sufficiently so to show mirror image reflections and so I dropped my colours into a still wet wash of pale grey to produce this soft-edged effect. The church steeple makes a strong accent and provides a focal point against the pale sky. The distant trees and buildings are treated more softly and their grey shadows – ultramarine and light red – help to suggest recession.

The riverside willows were each painted in a single wash of pale Payne's grey and raw sienna and their shadowed areas and trunks were added, wet in wet, with a much stronger mix of the same two colours.

better in a landscape if handled a little roughly and not made to look like architects' elevations. Buildings set at odd angles in groups make more attractive compositions than those strung out in a straight line. The strong and consistent treatment of light and shade will add to their cohesion and the impression of three dimensions.

The amount of detail you include will depend largely upon distance. If the buildings are close, some indication of material will be necessary but never try to paint every brick and tile; feature just a few and suggest the remainder. The effect of weather-staining and patches of moss and lichen are another matter and should always be included. The roofs and walls of more distant buildings can usually be suggested by simple washes, though the subtle

THE CHAPEL, KNOLE HOUSE

The splendid old beech tree on the left was, sadly, a casualty of the 1987 autumn gales. As this painting was a commission, the buildings called for accurate treatment but the foliage received looser handling to provide contrast. Quick, horizontal strokes of a No 14 brush produced the broken wash which suggests the texture of the foreground grass.

The building is balanced by the deeper tones on the left of the painting and these dark areas are relieved by the pale tones of the stone urns, to provide useful contrast.

addition of a second colour to the wash – perhaps green to denote algae – may add variety and interest.

Pay particular attention to windows. Far too often they are shown as repetitive rectangles of dark grey. If you look more closely you will see that they are affected by such things as the position and colour of curtains, the presence or otherwise of glazing bars and the amount of light, if any, that they reflect. They may still be handled loosely but they will look far more convincing if you have studied them carefully. Water can add an extra dimension to the landscape and give it added interest and depth. Farm buildings reflected in a pond, or a river meandering through the countryside, make appealing subjects and are well worth trying. Reflections can cause problems however carefully they are studied. Mirror images should generally speaking be avoided if the scene reflected is at all complex, or over-complication and confusion will arise. One sometimes sees reflections that are broken into tiny splinters of light and dark by an errant breeze ruffling the surface of the water. Little horizontal dabs of colour may capture the scene for the oil painter, but watercolourists have to use a different technique. They would do better to study the reflections through half-closed eyes to lose the fragmented detail, and then paint them in one operation, varying tone and colour as they go. For this approach it is necessary to have a number of prepared washes at the ready and to work

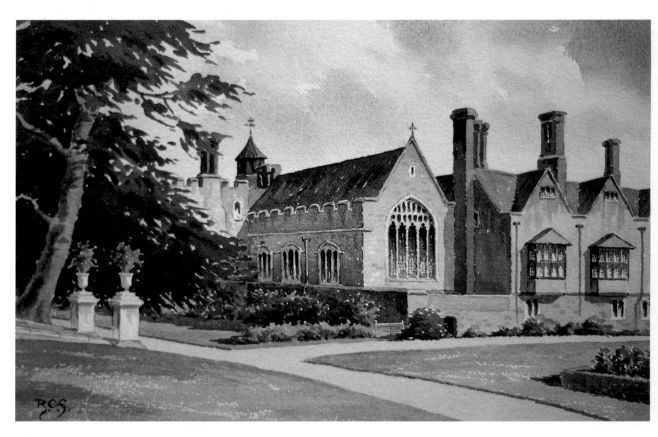

quickly. If the ripples are large enough to merit individual treatment, concentrate on the nearer ones and simply suggest the rest.

Breezes often give rise to light-coloured paths across areas of darker, smoother reflection. What happens here is that the little ripples so caused reflect the light of the sky above instead of the darker banks and trees beyond. These lighter areas are foreshortened and so often appear as narrow strips or lines of light colour. They can be put to good use if you wish, for reasons of contrast, to separate the scene above from its reflection. Remember, too, the old adage that dark objects are reflected lighter and light objects darker – it holds good most of the time.

Even when treating your reflections broadly and loosely, make sure that their tone and colour are roughly in the right place and correspond reasonably closely with what lies above.

Many of the points made in this chapter are illustrated graphically in the accompanying paintings.

TIMBLE VILLAGE, WHARFEDALE

This tiny Yorkshire hamlet provided a useful exercise in painting masonry of various kinds – the dressed stone of the cottages and the uncut material of the dry stone walls. A simple wash served for the more distant walls but more detail was required closer at hand. The old barn on the right was painted with a single wash of pale grey merging into green near ground level, with a few chips of white paper left to suggest the pale mortar courses. When this was dry some vertical strokes were added in pale green to represent weather-staining and a few random blocks of deeper grey were added. The shadowed gable end of the adjoining cottage was given similar treatment but in much deeper tones.

Chapter 9

ARTISTS OF STYLE

JILL BAYS

Although born in India, Jill Bays has lived and worked in England all her life. She trained as an illustrator at the Guildford School of Art where she gained a National Diploma in Design. On leaving she worked in advertising as a typographical designer and became a visualiser at a top London agency. After her two children had grown up she gained a Post-Graduate Certificate of Education and this was followed by a Bachelor of Arts degree in which the emphasis was on the History of Art. She is also a member of the prestigious Society of Women Artists.

She has taught Art and Pottery at various levels in Surrey schools and has also tutored painting holiday groups. She now paints full time and has received many important commissions from leading commercial organisations. She is represented in private collections all over the world.

Her work encompasses many subjects and although her studies of plants, flowers and gardens have gained wide recognition, she also excels at landscape to which she brings great freshness and style. She is an outstanding watercolourist with a genuine feeling for the medium, as is immediately apparent from her masterly handling of clear washes. She has a perceptive eye for line and composition and even her looser paintings have an underlying structure of design and order.

Her watercolours are always painted in the open air, in front of her subject matter, and this no doubt largely explains her ability to capture the atmosphere and the feeling of her chosen scenes. There is a delightful looseness about her style and she makes good use of the white of the paper which imparts freshness and sparkle to her work. Although the acquisition of style is not one of her objectives, her pursuit of excellence, her honesty of purpose and her natural feeling for her medium have combined to produce an individual style of distinction.

JILL BAYS' APPROACH

'All of my landscapes are painted before the subject; that is, on the spot. This to me is part of the enjoyable aspects of painting, being outside in the fresh air and having my subject in front of me. This can have its difficulties as the weather and temperature can be uncomfortable (I am lucky inasmuch as I have an enthusiastic painting companion, and it is good to be able to exchange ideas). This approach means that probably one can only have one session at the subject, but it makes for directness which I value.

'Ideally I like to see my subject in advance of painting, to ascertain light, time of day and so on. At home this is possible; however, if one is away there is always the excitement and challenge of new situations. It can take time to accustom oneself to certain aspects of a promising subject and there is always another approach.

'As regards style, I try to render what I see in front of me to the best of my ability, and not to worry about style. If one tries to paint in the style of someone else, difficulties are bound to arise. Mostly, I paint on stretched 140lb (300g) paper 15 x 22in (380 x 560mm). Time is often limited but I invariably start with thumbnail sketches to get the feeling of the subject and the composition. The subject is indicated with pencil, the sky is put in first as it is usually the lightest area. I like to capture the feel of the day if possible, and try not to worry if things go wrong, sometimes starting again or making a smaller painting in a sketch-book which is always with me. Mistakes which to me are glaring are not always noticed by the viewer!'

OLIVE TREES, GREECE

Artists visiting Mediterranean sunspots are invariably attracted by the form and colour of the ubiquitous olive. Olive groves certainly make appealing subjects but painting them convincingly and sensitively is no easy matter. In this delightful study Jill has captured their subtle grey-green colour and their form to perfection. Her light touch and her eye for line both contribute to the freshness and the rhythm of this most successful painting. Notice particularly the simple yet effective treatment of the foreground.

(Overleaf) SAILING AT SHEPPERTON

This painting captures all the bustle and activity of the weekend sailing club in action. With boats constantly changing position and the sails going up and down, quick decisions and speedy execution were imperative. Jill's bold and direct style has resulted in a painting that is lively, fresh and perfectly in tune with the subject. Notice how the strong, horizontal brush-strokes have imparted a lovely liquid shine to the water and how these, although similar in colour, contrast with the much softer treatment of the sky. Notice, too, how the touches of red in the sails register strongly against the complementary greens behind.

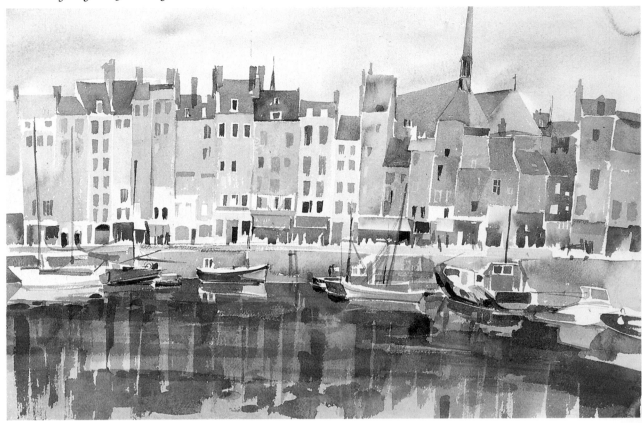

HONFLEUR

The harbour at Honfleur, a subject much loved by artists of all eras, has been painted many times, but Jill has brought a fresh vision to it. I particularly like the somewhat ethereal treatment of the tall, narrow harbour-side buildings with their softly contrasting colours, and the more strongly painted fishing-boats at anchor in the foreground. The backdrop of buildings contrasts tellingly with the looser but most effective handling of its reflection in the harbour below where it is modified by the local colour of the water. A painting full of atmosphere and subtlety.

THE RIVER WEY, SURREY ▷

This charming study of trees in full leaf and their reflections in the smooth water of the river shows the artist's ability to capture atmosphere with her soft, understated colours and her confidently applied liquid washes. The cool colours of the distant trees in the centre effectively suggest recession while the boat and buildings below provide the perfect centre of interest to which the lines of the river banks lead the eye. The treatment of the sky has been kept very simple to avoid competition with the scene below.

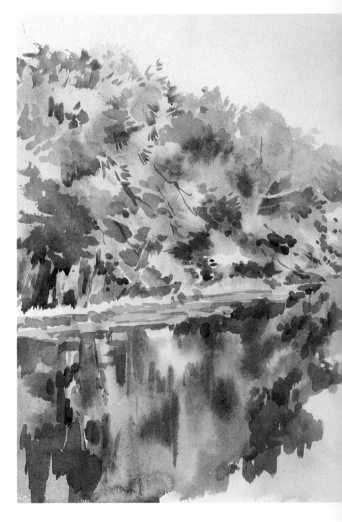

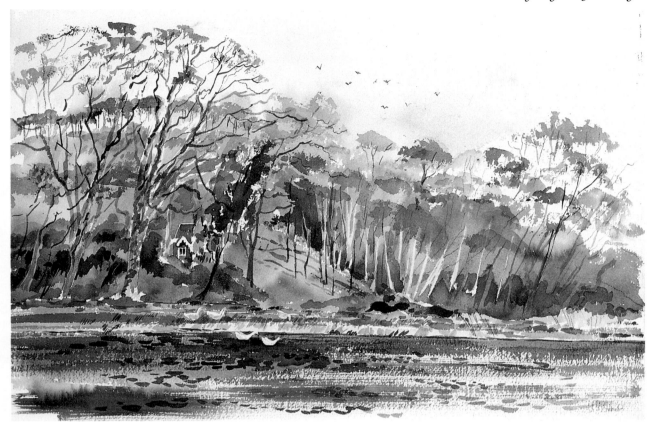

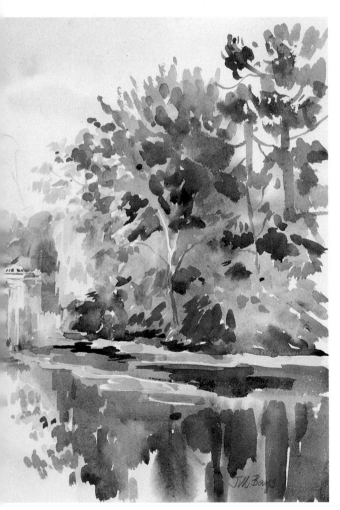

SURREY WOODS NEAR GUILDFORD

This lively scene was painted one bright and windy day
in March and the object was to convey something of the
atmosphere and feeling of the occasion. The artist has
captured the warm colouring of woods in spring, before
the leaves appear. The cool blue of the water contrasts
with the warm colours above and she has used a
dragged brush technique – quick, horizontal strokes of a
large brush – to portray the effect of light sparkling on
the water. Smaller, darker brush-strokes were then
added to indicate individual ripples. The whole effect is
of a bright, blustery day in early spring.

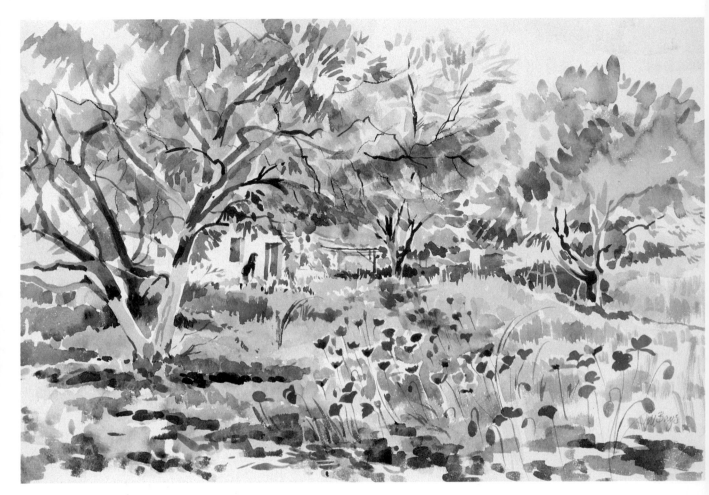

GREEK GARDEN

This painting of a typically informal Greek garden has been handled loosely and freshly and full use has been made of the white of the paper to impart an attractive sparkle to the scene. The soft grey-greens of the olive trees contrast effectively with the warmer yellows and reds below. Once again the foreground has been indicated loosely and impressionistically and so does not claim undue attention.

The artist's delicate but direct style is ideally suited to subjects such as this.

ALWYN CRAWSHAW

Alwyn Crawshaw was born at Mirfield, Yorkshire, and studied at Hastings School of Art. He now lives in Dawlish, Devon, where he and his wife, June, have opened their own gallery. He is a skilled and versatile painter and works in watercolour, oil, acrylic and pastel. He is a Fellow of the Royal Society of Arts, a Member of the Society of Equestrian Artists and a Member of the British Watercolour Society.

He is also a highly successful writer with the ability to convey his love of art to his readers who number well over one and a half million worldwide. He has written eight books in the Harper Collins 'Learn to Paint' series and several other successful art books.

With his lively and friendly personality he is much in demand on television and his twelve-part series on watercolour, entitled 'A Brush with Art', has been shown in Britain, Eire, Turkey, Italy and Singapore. Another series, on oil painting, has been filmed and a third has recently been completed. He has appeared on national and local television and radio.

He is a skilful and enthusiastic teacher and has made six videos on learning to paint which sell worldwide. He organises his own popular painting courses and demonstrates and lectures to art groups throughout Britain.

He has exhibited at the Royal Society of British Artists in London and won the prize for the best watercolour at the Society of Equestrian Artists' 1986 Exhibition. Fine art prints of his paintings find a ready international market and his works are found in private collections throughout the world.

His many one-man shows have been enthusiastically acclaimed by the critics and the art-loving public. He is listed in 'Who's Who in Art', 'Men of Achievement' and the Marquis 'Who's Who in the World'.

ALWYN CRAWSHAW'S APPROACH

'When I was at art school, I had three tutors, who introduced me to watercolour. Two of them were traditional in their approach, building up paintings with clean washes until the desired strength of colour and tone had been achieved. The other tutor was quite the opposite and would work at a painting in what seemed to me a non-structured way, very bold and with no apparent thought for paper or brushes. I used to hold my breath as she would say, 'give me your brush – do it this way', and my sable, which I treated like gold dust, was pushed around the paper like a scrubbing brush on a kitchen floor. I admired all three tutors and their work but the strange thing was I never thought of trying to copy the style of any of them. With oil painting it was different and I was always 'looking for a style' at art school. I think the reason is that watercolour is so immediate that you don't get time to 'copy style'. Everything is happening so quickly, but with oil time is not a problem. We used to start a painting in the 'style' of John Constable and finish like Van Gogh. Perhaps I have overstated this but only to make my point!

'My approach to watercolour over the years has been a mixture of my three tutors and my own experience. I suppose I am a traditionalist at heart, working with washes of colour and building up paintings with one wash on another, but the subject or the circumstances may change my methods. I have three distinct mental approaches to my painting. The first applies to small paintings, say, 8 x 11in (200 x 280mm), usually painted on cartridge drawing-paper or Bockingford watercolour paper and done on location. The object is to capture the spirit of the scene quickly. Anything goes with a painting like this, wet on wet, trying to hit the dark tones first time (no time for "building up" tonal areas). The two paintings No 1 and No 2 were painted like this. These paintings have a free and spontaneous look, but this was not a "style" I was trying to achieve; it was the circumstances of the painting that dictated the result.

'My second approach is very much my normal way of painting. Working outside on location, usually on 15 x 20in (380 x 510mm) paper and without the pressure of time, I gradually build up the painting tonally with a series of washes until I finish with the darkest areas. No 3 was painted in this way.

'Finally my third way of working is in the studio, where I have time and working conditions on my side. It gives me a chance to think and to indulge myself in experimenting with watercolour, which can be very exciting.

'These three approaches produce three different types of paintings. But the style is the same, the style can't change, the style is yours. Style is a natural evolution of an artist's work and it is this that makes the artist an individual.'

THE FLUTE PLAYER

This lively study was made in Italy, again on size A4 cartridge paper. To quote the artist, 'I walked into a small square in San Gimignano, an old mountain town in Tuscany, and heard the musician playing the flute. It was magical and I had to capture the moment. No time for thinking, just drawing and painting.' One should always have a sketch-book at hand to catch the fleeting moment and if there is time to add colour, so much the better. Although working at breakneck speed, the artist made time to consider his subject and sensibly placed the figure against a light-toned area of wall.

◁ Salisbury Cathedral after a Shower

This famous cathedral with its lofty spire has been painted many times but the artist has found something fresh to say about it. The painting was made in the field one early evening, after a shower of rain, and the wet, misty atmosphere comes across convincingly. The sky is a single variegated wash with just a few chips of white paper left to represent the highlights in the clouds and some soft grey dropped in, wet in wet, to suggest cloud shadow to the left of the spire. The trees have been handled as masses, with full washes of liquid colour.

An Italian Street

This quick impression was made on size A4 cartridge paper as a demonstration to a group of the artist's students. Apparently opinions differed on the wisdom of including the white car in the foreground but there is no doubt it strengthens the composition and introduces a modern note which provides contrast with the older buildings. The waving washing at top right adds a lively touch and the two tiny figures are perfectly placed to carry the eye down the narrow street. The style is loose and direct and the painting fresh and most successful.

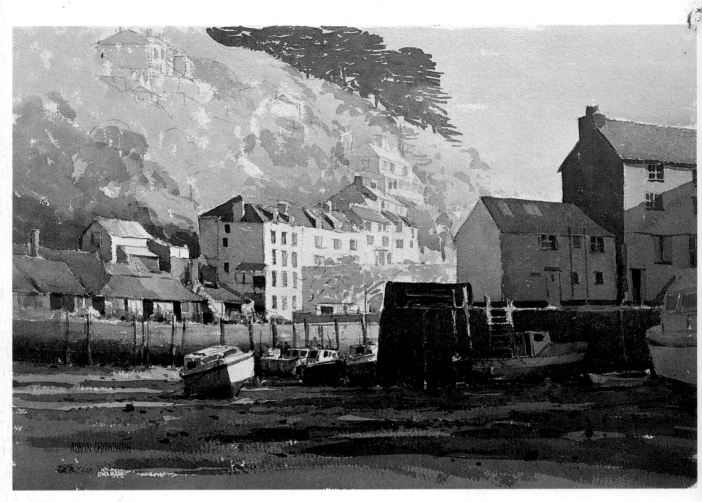

SUNLIGHT ON POLPERRO

In this delightful harbour scene, painted in the studio, the artist's main objective was to convey an impression of soft sunlight. He achieved this most effectively by leaving a lot of unpainted paper, using very pale colours on the background and buildings and working strong darks into the foreground to provide powerful tonal contrast. The shadowed area has been relieved by well observed touches of sunlight, notably on the tallest building, at the head of the vertical steps and on some of the boats. An object lesson on how to suggest light by placing darks alongside to provide contrast.

OUT OF THE WOODS ▷

A magnificent studio painting measuring 30 x 20in (76 x 51cm) and far too ambitious a project for working on location. Here the artist has built up the painting with successive washes of increasingly strong tone to achieve his effect. Notice how the winding track leads the eye into the heart of the painting where a signpost and two dim figures may just be made out against a patch of misty radiance behind, to provide the perfect centre of interest. Notice, too, the lateral tree shadows which break up the line of the farm track and the excellent treatment of the pale, dappled sunlight on the tree-trunks.

DRIFTING

Snowy landscapes can provide compelling subjects and the artist has done this one full justice. The warm grey of the winter sky has made the snow appear to shine, for the snow is simply the white of the Whatman paper, except where the loosely painted shadows reflect the colour of the sky. The distance has been simply but effectively suggested. The more distant trees are full, liquid washes of deeper grey against which the bare trunks and branches of the foreground trees register strongly. The hunched figure and the dog are ideally placed to provide a telling focal point.

ANTHONY FLEMMING

Born in London in 1936 into a famous artistic family, Anthony Flemming showed early promise and was encouraged by his illustrious father, Rowland Hilder. He trained at Goldsmiths' College of Art, studying painting, etching, lithography and industrial design. After a period working as a lithographer he travelled to Spain and Italy where he became interested in the Venetian School of painting.

When he returned to England, his technical drawings and aerodynamic studies were seen by the leading Formula One driver, Jack Brabham, who commissioned him to design the body and part of the chassis of a new racing car. This in turn led to design work for McLaren, Piper and McKecknie. In 1972, however, he made the momentous decision to return to full-time painting. His skill at draughtsmanship, his ability to capture the effects of light and his feeling for atmosphere quickly brought him recognition and success.

A lifelong interest in boats and water dictated his choice of subject matter. He learned to sail at an early age and the experience he accumulated gave him a broad physical and visual knowledge of water, sky, boats and coastal scenery.

Since that time he has extended his field to include landscape painting of the highest quality, both in oil and watercolour, at the same time never relinquishing his interest and expertise in etching and engraving.

These intuitive abilities have been reflected in the acclaim and rewards his work now commands. Successful exhibitions have been held in the USA, Japan and London, and in 1975 his work first appeared in calendars for Royle Publications.

Subsequently his work has been extensively used by several top charitable, commercial and banking organisations. He exhibits regularly at the RI and RSMA, and has executed numerous private commissions for major British and overseas companies.

The style and quality of his work continue to delight his many admirers.

ANTHONY FLEMMING'S APPROACH

'Style is not a subject that I consciously think about when painting. There are many things to consider when one sits in front of a view, but what style to paint in is not one on my mental list.

'When I sit down to capture a view I select the features that I feel encapsulate the essentials of what is before me. These features I usually indicate lightly in pencil. During this process I also reject, plainly leave out, other objects. These left-out objects may be such things as telephone poles and their wires, parked cars, a distant block of flats.

'Perhaps the leaving-out part of this selection is the most important part of making a painting, that gives an artist that individual style.

'Consider painting a tree. If one painstakingly painted every twig and every leaf in a photographic manner, it is likely that the result would have little style. But paint the same tree with a broad brush and in a brisk manner and the result will be quite different. I feel that it is this approach, block that tree in quickly and get on with the rest of the painting, that produces style. Every artist develops a kind of shorthand for dealing with familiar objects. It is this shorthand, economy of means, that you will recognise an artist by. It is this selection, simplification and technique that separates us from the camera.

'To coin a phrase, "I am not a camera".'

EDINBURGH

Light plays a vital role in this dramatic impression of the
Scottish capital. Everywhere in the painting there is
strong tonal contrast and it is this that creates the
powerful and atmospheric image. Notice particularly
how the sunlit buildings that comprise Edinburgh Castle
stand out against the slaty sky behind them and how the
shadowed side of the citadel hill contrasts with the paler
distance beyond. The dark vertical of the foreground
spire provides equally strong contrast with the sunlit
façade of Princes Street and helps the compositional
balance of the painting.

 A sky of this strength can look alarmingly over-
dominant when first applied, but the powerful treatment
of the landscape below quickly puts it back in its place.

HENLEY-ON-THAMES ▷

Another study of the Thames but one with an entirely
different mood. Here the scene is lit by an afternoon sun
which brings out the warm colours of brick and stone.
The sky has been very loosely painted in broad washes
and the strong treatment of trees and buildings below
helps to make it shine on the left of the painting. With a
busy scene such as this, any attempt to paint mirror
image reflections would have over-complicated the
composition and the artist has resolved the problem
with bold and loose treatment of the river. The willow
tree on the right and the dark sky behind it help to
provide compositional balance.

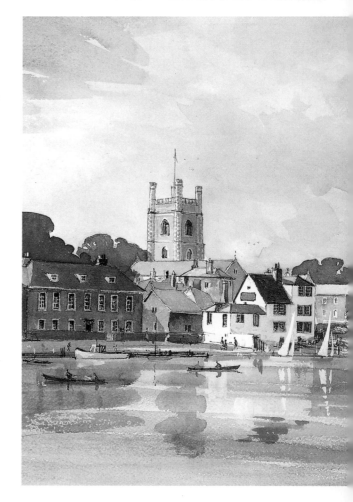

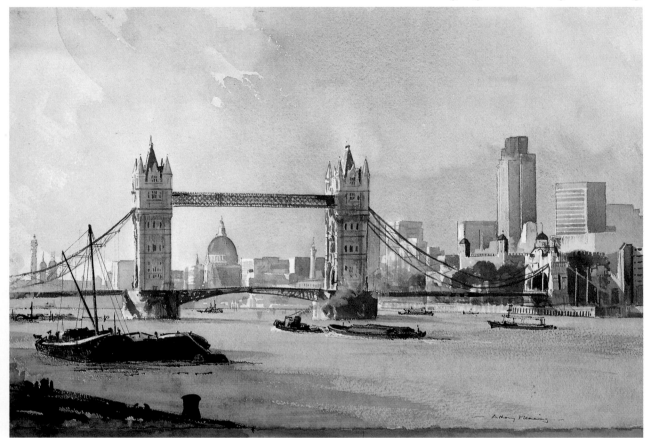

TOWER BRIDGE AND THE CITY

This painting of a famous London landmark is a splendid example of the artist's unique watercolour style. His understanding and appreciation of the effects of light come across strongly in his treatment of the sky and in the tonal contrasts of the buildings. His feeling for colour is apparent in the subtle and delicate washes which contribute a great deal to the success and the attraction of the painting. Notice how a strong feeling of recession has been created by the use of soft greys for the distance, warmer colours with more tonal contrast for the middle distance and powerful darks for the foreground.

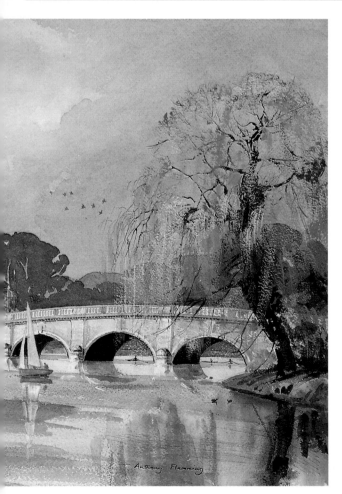

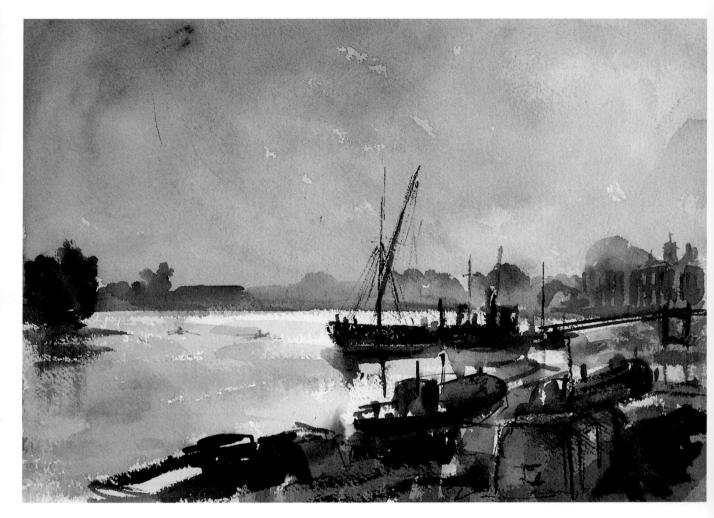

THE THAMES AT HAMMERSMITH

The artist's intuitive ability to capture the atmosphere and the essence of a scene comes across strongly in this quick but telling impression of the Thames. His skilful use of colour suggests the murk of an overcast London day yet the painting is alive with light and tonal contrast. Notice how the sailing barge is almost silhouetted against a patch of shining water and the manner in which the foreground boats have been loosely and economically handled, again in deep tones, to provide contrast with the pale colour of the river. The cool greys of the far bank suggest recession while the heavier clouds on the left and the deep-toned trees below help to provide balance.

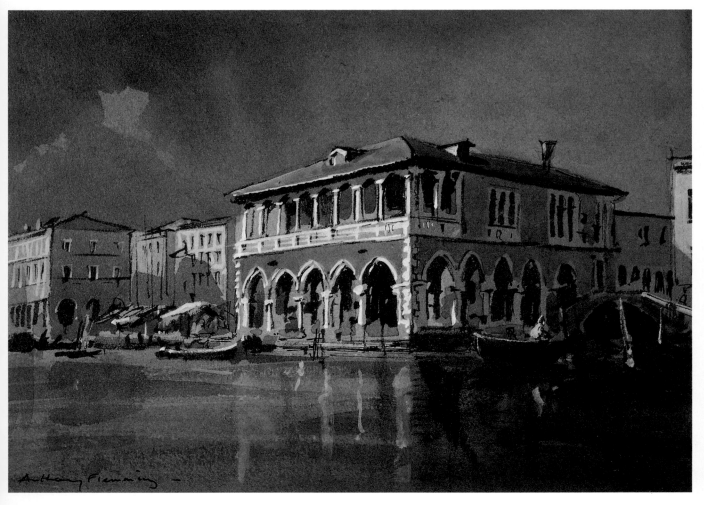

THE FISH MARKET FROM THE CANAL, VENICE

Sunlit buildings against a sombre sky can sometimes produce an unusual and interesting effect. The artist has made full use of this phenomenon in his study of the canal-side fish market, and the elegant buildings register dramatically against the browns and greys of the overcast sky. Full use has been made of tonal differences to produce a painting that is full of life and light. Once again the reflections have been merely suggested so that they do not compete with the detail above. The deep colour of the sky on the left helps to balance the weight of tone on the right of the painting.

(Overleaf) SCOTTISH ANCHORAGE

The artist's mastery of the cloudy sky is again apparent in this vigorous study of a Scottish loch. Loosely painted, with both hard and soft edges, it sets the scene and explains the strong tonal contrasts of the landscape below. This countercharge is particularly apparent in the lights and darks of the middle-distance headland which provides the centre of interest of the painting. The foreground has been treated very simply and directly so that it complements but does not compete with this headland. The treatment of the distant mountain range, indicated by a single wash of grey, provides similar contrast.

AUBREY PHILLIPS

Aubrey Phillips was born in the village of Astley in Worcestershire. He studied at Kidderminster School of Art, under the late C. J. Lavenstein, until the Second World War, when he served with the Army. At the end of the war, he taught Art for a time at an Army School near Cologne. On returning home he continued his studies at the School of Art in Stourbridge under E. M. Dinkel. In the following years he spent much time painting the lovely landscape of the Welsh Border country.

Dealing through agents in London he sold work for use on greetings cards, food packaging and even jig-saw puzzles. Greater success came later, with work accepted for London Exhibitions through the Federation of British Artists.

In 1966 he gained the highest award at the Paris Salon, a Gold Medal. In the same year he was elected a Member of the Pastel Society, and in 1969 a joint exhibition with a fellow artist was staged at the Piccadilly Galleries of the Federation of British Artists.

Meanwhile, further exhibitions, including one-man shows, were held in Civic Galleries in Worcester, Hereford and Gloucester and at the National Library of Wales in Aberystwyth. He began showing work at the Royal West of England Academy in Bristol, and in 1974 was elected to Associate Membership, becoming a full Academician in 1981. At about the same time he was made a Member of the Watercolour Society of Wales. His Army service qualifies him, as an elected Member, to exhibit with the Armed Forces Art Society at their annual shows in the National Army Museum in Chelsea.

He was a part-time lecturer at Malvern Hill College for over twenty years and now holds a similar post at Bournville College of Art.

He has written two books, one on the use of pastel and another on watercolour, and he contributes regularly to leading art magazines. In recent years he has concentrated on painting the remote places of Britain and his mountain and coastal scenes have received universal acclaim. He has the ability to convey a strong impression of atmosphere and space and his work is in increasing demand from discerning collectors and galleries.

AUBREY PHILLIPS' APPROACH

'For me, the essence of true watercolour is its transparency – the white of the paper showing through the washes creates a charming luminosity.

'Changing weather, mood, atmosphere, light and distance are the qualities which I attempt to convey, the inherent ingredients of our fickle British climate, so convincingly portrayed by the Early English School of Watercolourists of the late eighteenth and early nineteenth centuries, for whose traditions I have the greatest respect.

'I find that the natural behaviour of very liquid washes applied with a large brush is to blend together, creating a suggestion of form rather than clearly defined shapes. This applies particularly to my handling of skies and distant landscape, and it is these passages which I deal with first in a picture. This technique is usually described as "wet into wet". In general I work forward, through the middle distance towards the foreground, applying the lightest washes with as large a brush as possible, attempting to cover the white of the paper – unless of course, it is needed as a highlight as in snow, etc. I then follow with darker tones, drawing in the more definite forms of objects such as trees, buildings and so on. It may be necessary (usually when dealing with distant objects or reflections) to paint into some of the first washes before they are completely dry, giving a soft-edged effect. The final, more clearly defined shapes are dealt with when the paper is dry using the brush to draw and create form as necessary.'

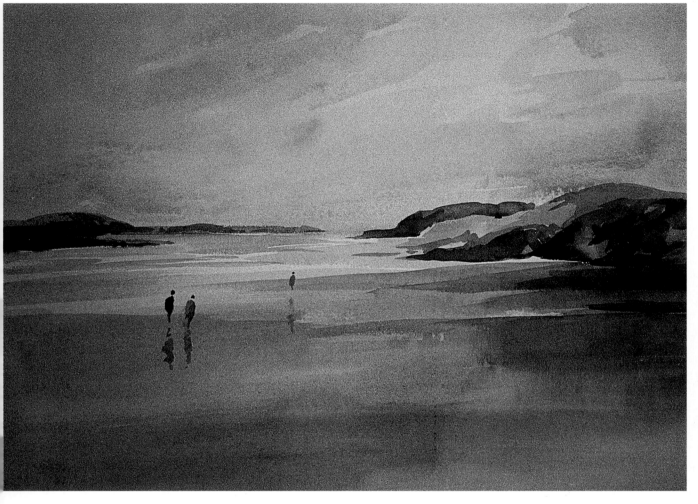

SUTHERLAND COAST

This coastal scene is typical of the type of subject the
artist delights in capturing and once again he has
produced a painting which is full of light and space and
atmosphere. The broad expanse of sand in the lower half
of the painting has been economically but effectively
established and the area of foreground water and wet
sand has been simply but convincingly suggested. The
skilful use of full, liquid washes ensures the freshness
and the clarity of the painting.

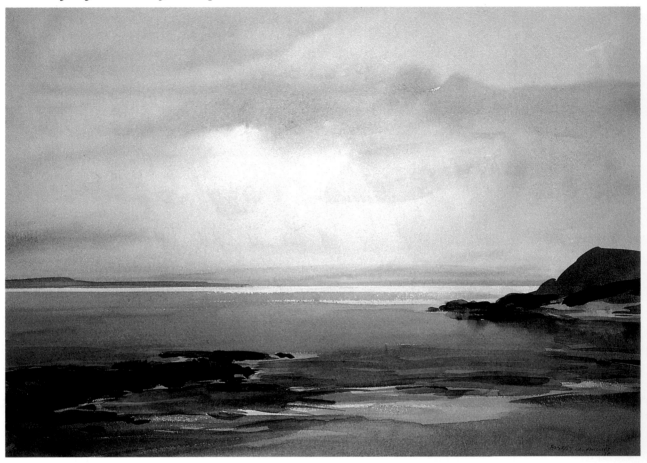

HEBRIDEAN COAST

Another deceptively simple painting which is all about light and space. The radiance in the lower sky and the shine on the distant water are virtually the white of the paper, and how well the artist knows how to preserve it to produce an impression of brilliant light. This impression is enhanced by the stark outline of the dark headland on the right, which is balanced by the deep-toned rocks on the left. The calm sea has been very simply but effectively conveyed and the absence of any sign of life conveys the emptiness and the grandeur of the Hebridean scene.

(Opposite, above) COTSWOLD CORNFIELD

This study of the Cotswold countryside shows the artist to be as much at home in tackling domestic scenery as he is in painting the wild places of the British Isles. His feeling for light and space is just as apparent in his sure handling of the sky, while the narrow blue-grey strip perfectly suggests recession into the misty distance. The cornfield has been very simply treated and the converging brush-strokes lead the eye firmly to the centre of interest. In his boldly painted lateral shadows the artist has used the roughness of the paper to convey a feeling of texture to the field of corn.

(Opposite, below) WINTER, THE BRECON BEACONS

Nothing in watercolour can be lighter than the untouched white of the paper and the artist has made effective use of this fact to represent the brilliance of the snow in this Welsh mountain scene. The boldly painted sky is somewhat deep-toned and this, by contrast, helps to make the snow appear even whiter, an effect which is further enhanced by the deep tones of the distant woods and the nearer trees. Notice how the lines of the freely painted foreground snow help to carry the eye into the heart of this delightful painting.

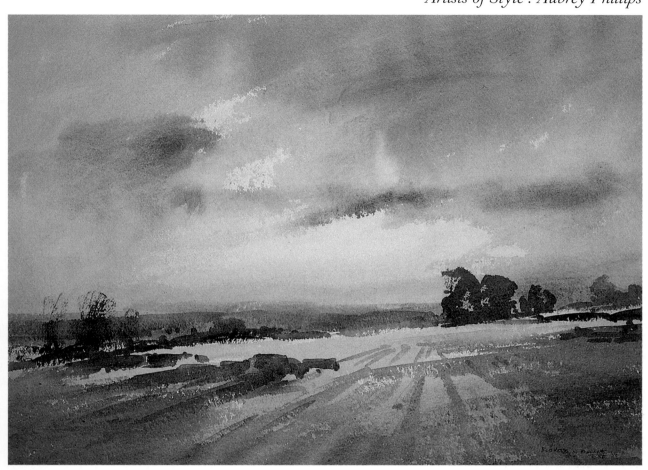

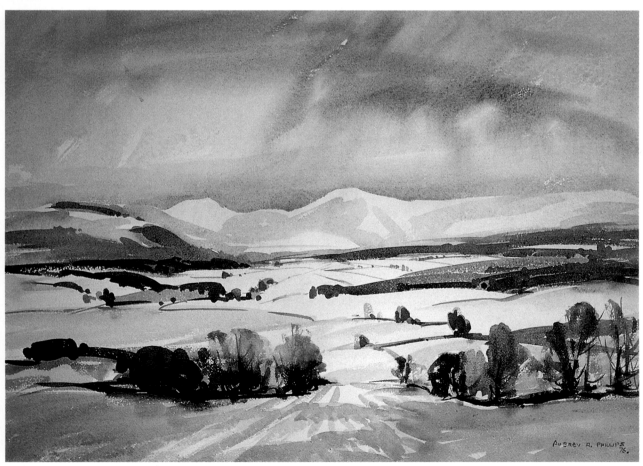

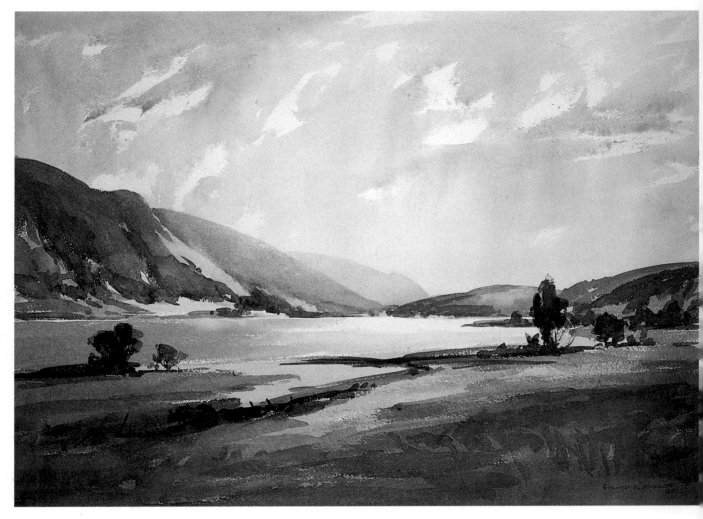

TAL-Y-LLYN, NORTH WALES

Aubrey Phillips is at his superb best when conveying the effects of light and space and this he does to perfection in this delightful painting of a North Wales lake. The radiance in the lower sky and the shine of the distant water are almost palpable and are conveyed by the use of full washes, simply applied, which allow the paper to shine through. The dark trees and banks provide dramatic counterchange and enhance the impression of shining water. The bold, loose handling of the foreground provides an object lesson in the avoidance of overworking this sensitive area.

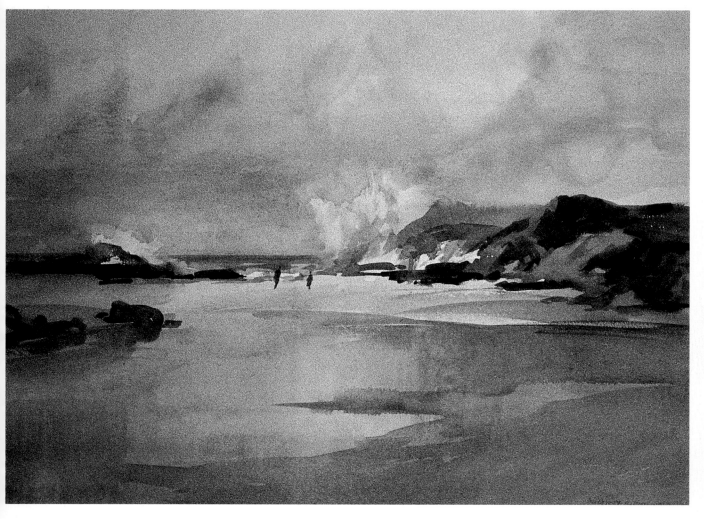

STORMY WEATHER, SUTHERLAND

The dark, racing clouds in this Sutherland coastal scene explain the wild and stormy seas which contrast dramatically with the expanse of calm water in the foreground. The artist has used tonal contrast to good effect in all parts of the painting and it is this that gives it life and movement. Although the sky is overcast, there is still plenty of light in the composition, notably in the strip of middle-distance sand, in the stretch of smooth water and, of course, in the breaking waves.

EDWARD WESSON

Edward Wesson was born in Blackheath, London in 1910. At school he excelled at games rather than academically and became captain of rugby. Although he did not take art very seriously as a schoolboy, and spent more time caricaturing his masters than he did developing his artistic skills, he did in fact succeed in winning the school art prize. It was not until about 1930 that he began to take art more seriously and paint in earnest.

During the war he was commissioned in the Royal Artillery and spent four-and-a-half years on active service in the Middle East and Italy. Towards the end of this service more opportunities for painting arose, particularly in Sicily and Italy, and his work developed accordingly.

During the post-war years he began exhibiting at the prestigious Royal Institute and the Royal Academy and in 1952 his genius received official recognition when he was made an RI. He later became an SMA (1957), an RBA (1963) and was invited to join the Wapping Group. In the 1950s he was commissioned to design posters for British Rail and the Post Office Savings Bank. When he finally decided to give all his time to art, he began to write for such magazines as *The Artist* and *Leisure Painter*, to demonstrate to art clubs and to undertake tutoring at art centres such as Dinton. He also ran his own art courses at various centres in the south of England, such as Corfe Castle, Wareham, Yarmouth, the Isle of Wight, Rye, Walberswick, Chichester and elsewhere.

With his direct style and skill as a watercolourist, his natural ability as a teacher and his bluff good humour he quickly became highly popular and was in great demand from art clubs and holiday course organisers. At the same time his work was becoming ever more sought after and was quickly snapped up by the galleries.

In 1982 he wrote his autobiography, 'My Corner of the Field', which was beautifully illustrated by many of his finest works. This, a limited edition of 2,000, was quickly sold out and has since become a collector's item.

Since his death in 1983 he has been remembered with affection and respect by his army of admirers.

EDWARD WESSON'S APPROACH

The Wesson approach is perhaps best summed up in the following excerpt from his autobiography:

'A medium such as watercolour must have its limitations. It doesn't bear being pushed about and worked on without losing its main quality. In order to get over this problem, we need to simplify the subject in front of us so that there will not be the need for any over-working or fiddling. A range of hills in the distance must be captured in one brushstroke. Clumps of trees must be treated as masses and put down in their respective correct tones. Some definition will, of course, have to be added, such as branches in the trees, in order that the mass shall have meaning. These additions will not be so much painting as drawing with the brush.

'Another very important thing I have always made a point of remembering is that next to all our materials, colours, brushes and other equipment, the most important thing is our paper. I have talked earlier on the subject of paper and how important it is for each of us to find the surface that suits us best. To me the paper is half the battle, not only because we have found it suits us, but because we must make very good use of it by trying to lay all our washes to it once only. This makes for a luminosity which I don't see in any other medium. Further, we can actually leave the paper, in certain circumstances, thus giving a natural sparkle to passages which no amount of Chinese White could achieve'.

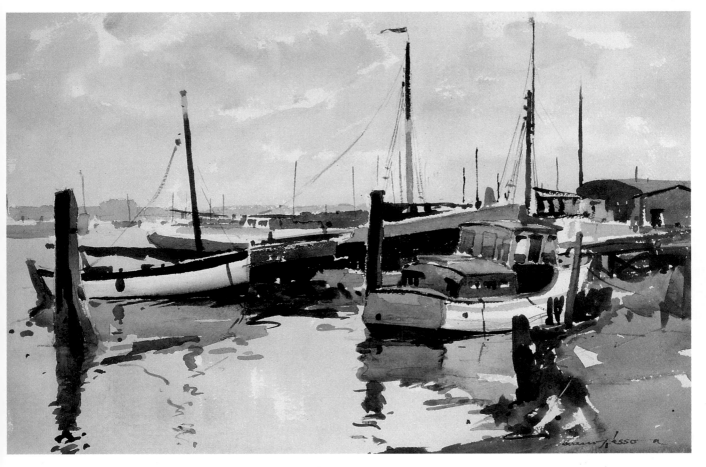

HEYBRIDGE BASIN

I believe this to be one of Edward Wesson's finest paintings, and it catches the atmosphere of its subject to perfection. It is full of interest and movement, but everything has been put down with the artist's customary economy and freshness. He has made the most of the strong tonal differences in the foreground and these contrast with the soft greys of the distance to create a powerful feeling of recession. The sky is treated very simply, in pale tones, to avoid competition with the busy scene below, and its radiance is reflected in the beautifully painted shining water.

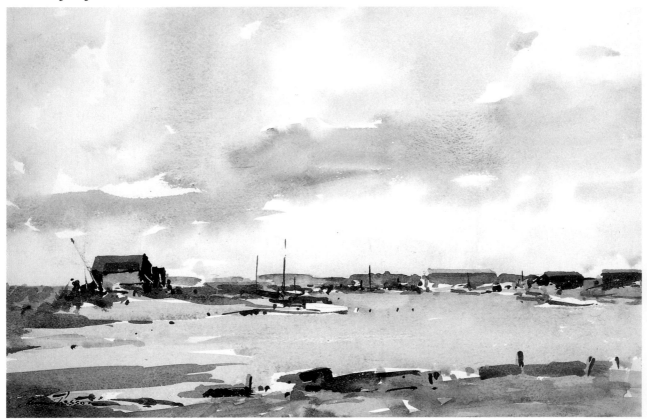

WALBERSWICK, SUFFOLK

This is an area beloved of artists and the fisherman's hut on the left is arguably the most frequently painted in the country. The river estuary, with its moored boats and maritime clutter, contains a wealth of subject matter and Edward Wesson chose it as a centre for one of his popular watercolour courses.

This painting is a symphony of soft browns and greys and although the colours are understated, they are full of subtlety. The cloudy sky, beautifully captured with bold, liquid washes, is full of interest and for this reason a low horizon was adopted. The detail below is very loosely suggested and some of the boats are little more than chips of white, untouched paper.

WINTER FEED IN WYLYE VALLEY ▷

This is typical of the sort of winter landscape the artist loved to paint and the treatment is vintage Wesson. Here there is warmth in the lower sky and this is echoed in the soft browns of hedge and foreground. The line of cattle, their brown, white and black shapes loosely indicated, serve to link the tall trees on the left with the area of shadow on the right. Notice how the skilful use of dry brush technique has suggested the bare twigs of the winter trees and how the cool grey wash behind the cattle perfectly represents a stand of more distant trees.

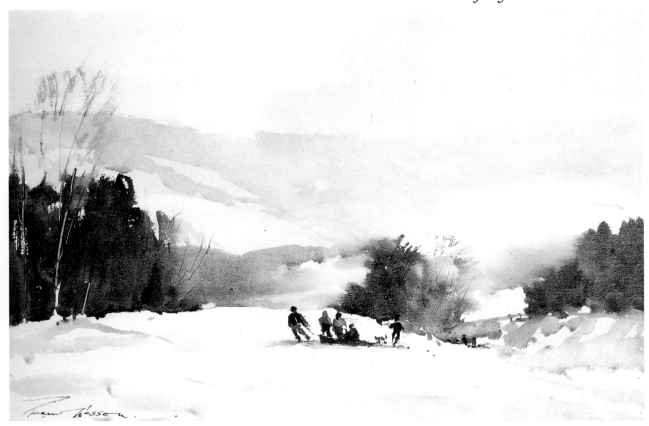

WINTER SPORT AT NEWLANDS CORNER

This watercolour is a telling example of the magical effect of snow on the landscape. It was painted on the spot in about half an hour, the figures of the children being added later from memory. The main feature of the painting is the dramatic tonal contrast between the dark evergreens (varying mixtures of burnt umber and Winsor blue) and the soft blue greys of the distant downs. Notice particularly the alternating hard and soft edges of the dark trees against the misty distance, and recognise the mastery and control of the medium which such subtleties demand!

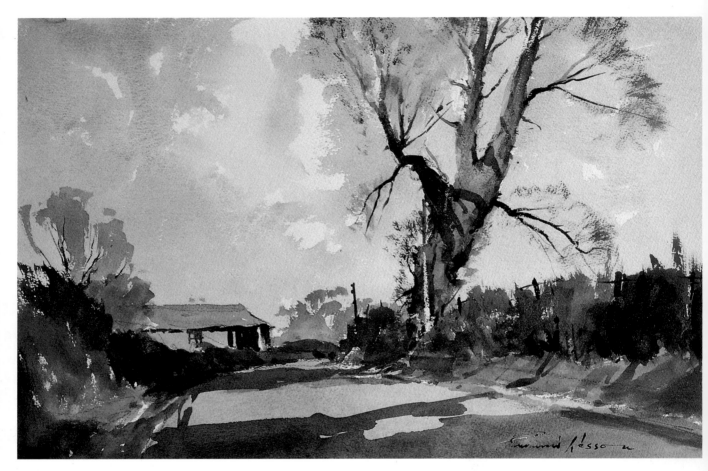

WINTER LANE

The main feature of this painting is, of course, the big tree just to the right of centre. It is balanced by the line of shadowed hedge and the single-storey building on the left. This tree repays careful study. Notice, for example, the tonal contrasts it contains – the shadowed underside of the forward-pointing branch, the dark branches in the shadow of the trunk and the much lighter, warmer tones of the sunlit areas. Notice particularly the branch shadows falling obliquely across the trunk – so often omitted by beginners! The liquid foreground shadows and the soft greys of the distant trees both play an important part in this simple yet effective painting.

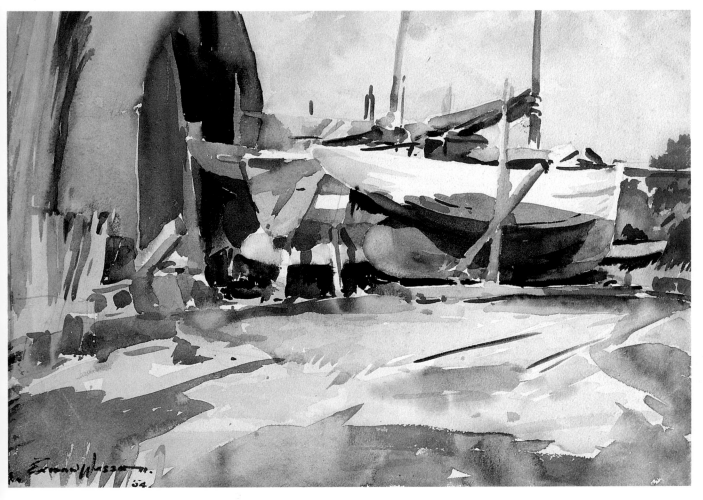

ON THE STOCKS AT BIRDHAM POOL

The strong shapes of these sturdy craft make an interesting pattern which is balanced by the shadowed elevation of the large Nissen hut on the left. The nautical clutter at the base of the hut – inseparable from the typical boat-yard – has been loosely but firmly suggested. It is a mistake to tidy up such a subject, as orderly-minded painters sometimes do, for the clutter is part and parcel of the scene and helps to give it character. Notice how the patch of green foliage on the right strengthens the complementary red of the nearest boat.

JOHN YARDLEY

A native of Beverley, Yorkshire, John is fifty-eight, married with three children and has lived in Reigate, Surrey for over thirty years. Receiving no formal art training but showing an interest in drawing from an early age, he began painting in 1953 after completing National Service. He left banking in 1986 to take up painting full-time, since when his reputation has grown rapidly and his paintings take pride of place in private collections across the country.

Having painted almost exclusively in watercolour for many years, he is now equally happy with oils. His continuing development is also apparent in his ever-widening range of subject matter. Pure landscapes are now giving way to scenes where figures play a more important role, such as the seaside, village cricket, street, park and café. Many of his flower paintings are given interior and garden settings.

His recent one-man shows have been highly successful and his growing popularity with collectors has been coupled with increasing recognition from the art world. It has always been a source of great pleasure that his work is acquired by fellow painters. In 1989 he won the Catto Gallery award at the RWS Open Exhibition; the following year he was elected a member of the RI and was awarded the Watercolour Foundation prize at their annual exhibition. A selection of his work was included in Ron Ranson's popular book *Watercolour Impressionists* (David & Charles, 1989) and in 1990 Ron Ranson published a book devoted solely to John's painting, *The Art of John Yardley* (David & Charles).

He is much in demand as a tutor and was one of those who in 1983 succeeded Edward Wesson at Phillips House, Dinton, where he now teaches for four weeks each year. He also conducts a one-week course at Dedham Hall, in the 'Constable Country' of Suffolk.

John Yardley is one of Britain's finest contemporary Impressionists. A rare ability to convey all the atmosphere of a scene with just a few well-placed brush-strokes combined with extraordinary powers of observation make him a worthy successor to Edward Seago.

JOHN YARDLEY'S APPROACH

'There is nothing unusual in my approach to watercolour – I prefer a loose style which leaves something to the imagination but at the same time it must be an interesting composition allied to a first-time application of colour. Having painted more or less unpopulated landscapes for many years I now prefer subjects with figures, particularly café scenes, interiors, gardens, etc. Always I have needed something with a 'subject' as opposed to the panoramic type of composition. Background harmony is important, particularly as to shape and silhouette, and my approach revolves around everything merging satisfactorily. This is difficult to explain in print – I mean having passages of colour merging/fusing and the avoidance of "edges" which draw attention to themselves. For similar reasons I play down the base or lower side of a subject, again to focus attention on the more important upper portion. From some of the paintings illustrating the article it can be seen that walls, windows etc, simply tail off as also the legs of figures; the shoes are not painted! Anything which draws the eye away from the main point of interest should be eliminated.

'All the time I am striving to "suggest" in paint and so let the viewer decide what is to be seen. This applies particularly to the previous remarks on buildings where the lower part is faded out. In, say, a street scene with figures the viewer knows simply by the placement of the main bulk of the building/figure where a wall meets the ground or a foot the pavement. Carrying this a stage further, a foreground figure may be painted with reasonable clarity; one slightly behind, less so; whilst those in the background may be just splashes of colour – we *know* they are figures. I apply the same process when painting flowers; one or two blooms in some detail while others are allowed to merge with the foliage.'

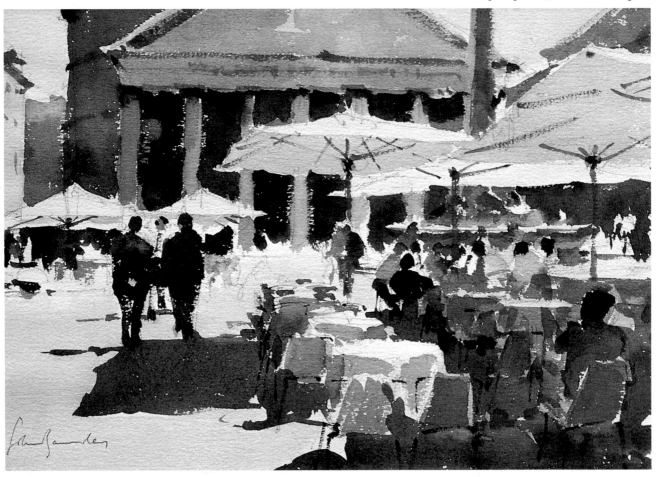

PANTHEON CAFÉ

This animated street café scene is bathed in warm, lateral sunlight, the strength of which is emphasised by the depth of the cast shadows. The lively composition owes much of its effectiveness to the skilful arrangement of lights and darks – the white of the foreground sunshades against the dark buildings beyond and the two upright figures on the left almost silhouetted against their contrasting pale background.

Notice how the artist has captured the subtle warm colour of the underside of the sunshades to perfection and how he has managed to convey the impression of a busy scene with a masterly economy of brush-strokes.

PETUNIAS

This attractive little painting is an object lesson in making something worthwhile of a very simple subject. The essential process is the absorbing of the scene, the mental simplification of its components into terms with which a direct watercolour technique can cope, the conscious grouping of lights and darks and the bold, confident application of paint. The feature of the painting is the placement of the pure white blooms against the dark backdrop of shadowed foliage to produce a breathtaking tonal contrast. The flowers, the stone urn and its pedestal are painted crisply and so stand out boldly against the more softly handled background.

123

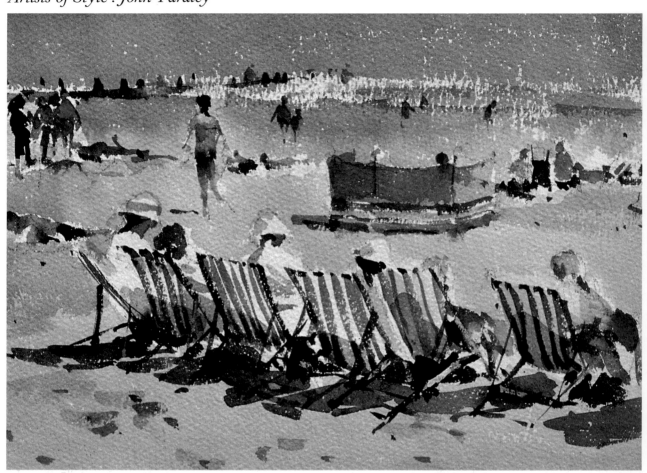

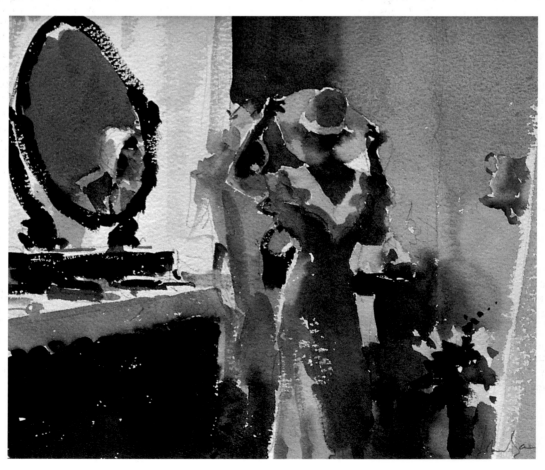

(Opposite, above) RELAXING

Here the artist has captured something of the essence of the English seaside holiday with his customary direct style of painting. The figures are very simply indicated but such is his extraordinary power of observation that they are all totally convincing. The sea is simply a quick lateral stroke of a big brush, wielded so as to leave white specks of untouched paper, and these perfectly represent the sun sparkling on the water and the white of breaking and spent waves at the water's edge. Notice how the paler colour of the foreground, with the few random footmarks, effectively conveys the feeling of dry, powdery sand.

(Opposite, below) THE NEW HAT

The artist's understanding of the effects of light contributes enormously to the success of his work. This charming study, painted mostly in muted greys and lit from the softly curtained window on the left, is a case in point. The loosely painted mirror stands out boldly against its pale background and the tones have been so arranged that the figure also contrasts with its background, though with greater subtlety. Only the lower part of the shadowed skirt blends into the background, with a lost-and-found treatment. I particularly liked the handling of the translucent material of the subject of the painting – the elegant hat.

ROME STREET

This brilliantly lit street scene, painted looking directly into the sun, is a fine example of the artist's ability to capture the effects of strong sunlight. We can almost feel the heat beating down and reflecting from the roadway. Once again effective counterchange is the secret, and the very pale colour of the road surface contrasts dramatically with the deep tones of the figures and the shadowed buildings beyond. Notice how the chinks of white round the heads and shoulders of the pedestrians produce a halo effect which makes them stand out against the dark background. Although this painting relies heavily on tonal contrast for its effect, there is plenty of rich colour in the dark buildings.

(Overleaf) KINGSTON LACY

This delightful painting is typical of the artist's brilliant handling of the interior scene and its success hinges largely upon his understanding of tone and his treatment of light. The large window is simply the white of the paper and its light is reflected in the polished surfaces in various parts of the stately room, giving the whole painting a delightful sparkle and vitality. With a subject of this sort it would be all too easy to begin to labour over the detail, but here the artist has succeeded in conveying it all while maintaining the freedom and the freshness of his brush-strokes.

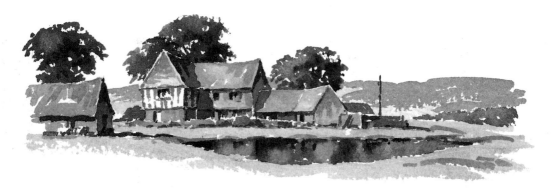

INDEX

Page numbers in *italic* indicate illustrations.

Index

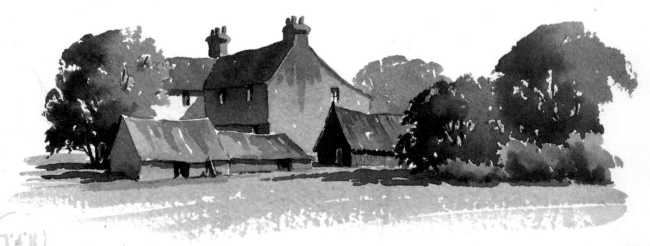